MAKING MEMORY MATTER

D0700729

MAKING MEMORY MATTER

Strategies of Remembrance in Contemporary Art

LISA SALTZMAN

The University of Chicago Press Chicago & London

Lisa Saltzman is associate professor of history of art at Bryn Mawr College.

The University of Chicago Press, Chicago 60637
The University of Chicago Press, Ltd., London
© 2006 by The University of Chicago
All rights reserved. Published 2006

Printed in the United States of America

15 14 13 12 11 10 09 08 07 06 1 2 3 4 5

ISBN-13: 978-0-226-73407-1 (cloth)
ISBN-13: 978-0-226-73408-8 (paper)
ISBN-10: 0-226-73407-2 (cloth)
ISBN-10: 0-226-73408-0 (paper)

Library of Congress Cataloging-in-Publication Data

Saltzman, Lisa.
 Making memory matter : strategies of remembrance in contemporary art / Lisa
Saltzman.
 p. cm.
 Includes bibliographical references and index.
 ISBN 0-226-73407-2 (cloth : alk. paper)—ISBN 0-226-73408-0 (pbk. : alk. paper)
 1. Memory in art. 2. Identity (Psychology) in art. 3. Art and history.
4. Art, Modern—20th century. I. Title.
 N8224.M45S25 2006
 701—dc22
 2006006821

⊗ The paper used in this publication meets the minimum requirements of the
American National Standard for Information Sciences—Permanence of Paper for
Printed Library Materials, ANSI Z39.48-1992.

CONTENTS

ILLUSTRATIONS

ACKNOWLEDGMENTS

Much is owed to many. First and foremost, I am deeply indebted to the Radcliffe Institute for Advanced Study. In 2002–3, I had the extraordinary privilege of an entire year in which to dedicate myself to this book project, completing its research and beginning its writing in a context that was nothing short of idyllic. To my fellow fellows and to the director, Judy Vichniac, I am eternally grateful.

It is also thanks to a very generous junior leave policy at Bryn Mawr College that I was able to begin this book. Without that critical year in New York in 1999–2000, I never would have had the degree of exposure and access to the contemporary art that grounds and inspires this project.

I have also had the good fortune to present parts of this project before a range of engaged and exacting audiences. My very first thoughts on what I then termed an "aesthetics of remembrance" were shared with an audience at Reed College, thanks to the generosity of the Robert Lehman Foundation and the honor of an invitation from their faculty in art and art history. As the project neared its completion, I was given the opportunity to present its structuring ideas in the form of a keynote lecture at the symposium "Out of Europe: History, Memory and Exile since 1945," hosted by the Center for German and European Studies at the University of Wisconsin–Madison. And throughout the years, the Center for Visual Culture at Bryn Mawr College has been a consistently generative and generous context in which to test my work.

If there is a single debt of gratitude, it is to my friend and collaborator Eric Rosenberg, with whom I had the pleasure of working on our coedited volume *Trauma and Visuality in Modernity*, which, conceived and realized during the very same years as this book, informed and an-

imated much of its thinking. I have also benefited immeasurably from the wisdom and sustenance offered by other friends and colleagues. This book would not have been completed without their involvement, whether as readers or interlocutors. It is thus that I offer my thanks as well to Anna Chave, Catherine Conybeare, Liza Johnson, Madhavi Kale, Homay King, Gwendolyn DuBois Shaw, Joanne Stearns, and Isabelle Wallace.

Bryn Mawr, PA
August 2005

1 NOTES ON THE POSTINDEXICAL

An Introduction

*Enough and more than enough
has now been said about painting.*

PLINY THE ELDER

"All agree that it began with tracing an outline around a man's shadow."[1] The object whose beginnings are affirmed here is art, the art of painting. It is a coming into being that, like a primal scene, is witnessed, belatedly and repeatedly, through its narration and depiction, in this case, within the history of art, or indeed, within the history of art history. It is a tale of conception in which a potter's daughter traces the shadow of a human figure upon a wall. This myth of origins is made known through an extensive body of canonical texts and images, first and foremost, Pliny the Elder's *Natural History*. As Pliny recounts the origin of painting, explicitly relinquishing in this tale any privileged or unique claims to the event as it might be located in time or space, in a past that we might call history:

> The question as to the origin of the art of painting is uncertain. . . . The Egyptians declare that it was invented among themselves six thousand years ago before it passed over into Greece—which is clearly an idle assertion. As to the Greeks, some of them say it was discovered at Sicyon, others in Corinth, but all agree that it began with tracing an outline around a man's shadow and consequently that pictures were originally done in this way.[2]

Pliny then goes on, in an account that no longer concerns itself with painting but with "the plastic art" of sculpture, to repeat and expand this tale of the Corinthian potter's daughter tracing the shadow cast by the human figure:

> Enough and more than enough has now been said about painting. It may be suitable to append to these remarks something about the plastic art.

It was through the service of that same earth that modeling portraits from clay was first invented by Butades, a potter of Sicyon, at Corinth. He did this owing to his daughter, who was in love with a young man: and she, when he was going abroad, drew in outline on the wall the shadow of his face thrown by the lamp. Her father pressed clay on this and made a relief, which he hardened by exposure to fire with the rest of his pottery; and it is said that his likeness was preserved in the Shrine of the Nymphs until the destruction of Corinth by Mummius.[3]

As I will contend, both in the course of this introduction and throughout the book that follows, the tale of the Corinthian maiden may be enormously productive as a paradigm for considering the art of the present. A story in which anticipated absence inspires and grounds the birth of pictorial, and then sculptural representation, Pliny's tale presents that mythic moment when imminent loss drives the impulse to record and remember. A body, soon to be borne off by the forces of history, into war, into exile, if not also into death, is commemorated through a sequence of decidedly visual strategies and inventions. In that primal scene, visual representation takes shape, takes form, takes place as a ritual of remembrance.

If I am compelled to return to a tale of painting's origins in the aftermath of painting's postulated end,[4] it is neither to reify origins as a recuperable site of knowledge nor to insist upon memory as an essential category of visual representation. Rather, I invoke this story for its allegorical potential, for its striking ability to organize an account of aesthetic preoccupations of the present, of art at the end of one millennium and the dawning of another. For I am convinced that this tale of loss, in which lamps and shadows, outline and relief, walls and shrines are put, by a daughter and her father, toward the task of remembering an absent and desired body, presents us with a paradigm for theorizing the representational strategies of the present. Projection, silhouettes and casting, such are the representational strategies described in Pliny's tale. And such are the strategies, the techniques and technologies, evinced in the present, a moment in which forms of photography, video, and installation have all but eclipsed painting as the preeminent form of visual representation.

Conjured in Pliny's tale are techniques that, unlike painting, bear something of a relationship of physical contiguity to their subjects. A luminous flame as a means of casting the shadow of the body before it, a drawn outline as a means of capturing the evanescent image of that body, a sculptural cast as a means of reconstituting and concretizing something of that lost body: in Pliny's tale, much as we may see the

seeds of an iconic form of representation, namely, drawing and figure painting, we are also presented with an art of the index, with strategies of representation that structure the visual object as the material trace of a fugitive body.

It also bears underscoring, before advancing any further, that the central protagonist of Pliny's tale is a woman, a daughter. In a reversal of cultural conventions both generational and gendered—cultural conventions that have irrefutably shaped the practice of both art and its history—it is a neither a father nor a son, but a daughter, poised at the mythic moment of aesthetic origins. Even if the father will go on to cast a relief, a sculpture, a three-dimensional likeness that will be preserved (until its subsequent destruction) in the consecrated space of the shrine, the father's position in the origin myth is secondary, not primary. It is she, the daughter, who produces the first image, whose act of drawing holds within it the very future of figurative painting. And it is she, moreover, who forges with her tracing of the shadow that foundational conjunction between the work of remembrance and the visual field.

That it is a daughter who determines, with her anticipatory gesture of grief, the link between representation and remembrance, certainly provides a means to think productively, perhaps even, differently, about the visual field and its history.[5] For difference does structure the tale, even if that difference may not, in the end, be a question of *gender* but rather, of *genre*. Where the daughter's drawn silhouette may be seen to acknowledge loss, offering no more than the inscription of a line around an empty center, the contour of an immaterial shadow, the father's sculptural cast might be said to disavow loss, seeking to bring the body back, if not to life, and if not to her, at least to sculptural form. In other words, though both father and daughter offer figurative forms of commemorative representations, her anticipatory aesthetic act of tracing a shadow ultimately refuses the fetishistic function of representation, where as the father's compensatory work of sculptural casting attempts to restore a certain material, if not, in the end, bodily fullness and presence.

Here I should pause to acknowledge that I am by no means alone in returning to the figure and story of the Corinthian maiden. There is a long textual and pictorial history that precedes, and in many ways, predicts my own encounter with the classical text. Over the centuries, Pliny's tale of the origins of painting has captured the imaginations of many a philosopher, aesthetician, artist, and art historian. After Pliny, versions of the tale appeared in such textual sources as Quintilian, Alberti, Leonardo, Vasari, and Diderot, and in such pictorial sources as

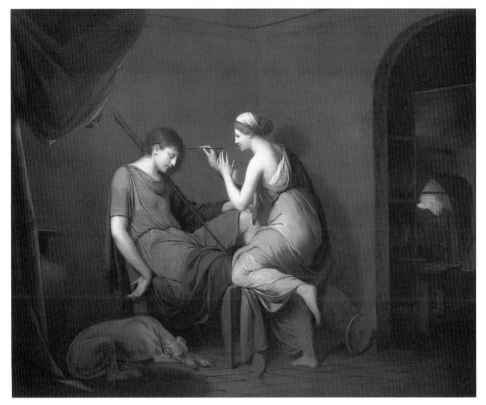

FIGURE 1 Joseph Wright of Derby, *The Corinthian Maiden,* 1782–84. Oil on canvas. Paul Mellon Collection. National Gallery of Art, Washington.

Murillo, Joseph Wright of Derby, and Daumier (figure 1).[6] Interest in the tale has persisted into the present, with some art historians particularly concerned with pursuing the significance of the tale's reemergence in certain historical moments. For example, Ann Bermingham, as a historian of artistic modernism, uses the treatment of the tale in late eighteenth-century Britain to explore the gendered distinctions between fine arts and craft at the moment of the founding of the Academy.[7] And Geoffrey Batchen, as a historian and theorist of photography, explores the late eighteenth-century interest in the tale as exemplary of a moment when the idea, if not the effect, of photography was born.[8]

Batchen's account is explicitly indebted to a set of theoretical engagements with the legend, foremost among them Victor Burgin's essay "Photography, Fantasy, Function" and Jacques Derrida's *Memoirs of the Blind.*[9] For Burgin, who is deeply indebted to psychoanalysis, the tale is

a means of placing desire at the origins, ultimately collapsed in his account, of painting and photography.[10] For Derrida, who produces an evocative account of the tale as it pertains to memory, an account of memory that is also deeply indebted to Baudelaire,[11] Pliny's tale is a significant, though by no means exclusive, point of departure for his wide-ranging rumination on self-portraiture and the activity of drawing. In Derrida's text, the tale is taken up in the service of a larger account of artists' impotence and blindness and art's incapacity and failure. For, on Derrida's account, to draw is to look away, to shift one's gaze from oneself or the object of one's gaze to the subject, the task, of representation.

It is as well the question of drawing, particularly, of the *trait* (mark) of drawing, as it was pursued first by Hubert Damisch in his *Traité du Trait*, that motivates Michael Newman's philosophical engagement with the Corinthian maiden's tracing of the shadow in his essay, as the title makes manifest, on "The Marks, Traces and Gestures of Drawing."[12] And it is then specifically the shadow that is of organizing concern in the work of Victor Stoichita, who uses Pliny's tale, along with Plato's allegory of the cave, to theorize the foundational role of the shadow in both aesthetics and epistemology. Stoichita discusses the fact that the first act of visual representation was the result not of direct observation of the human body, but of the capturing of the body's projection, in profile, the circumscription of a shadow, a representation of a representation, a copy of a copy. And while Stoichita briefly suggests that this resulting form might serve as a memento, a "mnemonic aid" with a propitiatory value, his larger claim is to suggest the ways in which the paradigm of the "shadow stage," one founded in a relation to the other, a love of difference, comes to be supplanted by a specular relation of sameness, by the Ovidian myth of Narcissus, by the love of the same, by what we would call, in the aftermath of Lacan, the mirror stage.[13]

For all of the ways that I am indebted to the accounts that precede mine, what distinguishes my invocation of the story of the Corinthian maiden is my attention to its unanticipated and, as yet, unexplored relevance to a set of aesthetic concerns and practices in the present. That is to say, my interest in the tale is in its potentially paradigmatic status, the model it provides for isolating and interpreting the various visual techniques and technologies through which the work of memory is performed in contemporary artistic practice. In a cultural present that is consumed by the concept, if not always the actual work of memory, Pliny's tale allows us to understand something of how and why memory and visual culture are conjoined in the present, how and why it is

through certain types of visual objects that we are able to bear witness, even if only belatedly and obliquely, to the histories that at once found and confound our identities.

Certainly, the representational strategies at stake in the account that follows are not the only visual means of encountering history in the present. There are instances in postwar practice when painting itself takes up the task of approaching, even if asymptotically, the subject of history, moments when painterly practice comes to function as an active agent in the cultural production of memory. Where Frank Stella's obdurately abstract, minimalist black paintings might be understood to have refused figuration as a means of expressing the impossibility of producing history paintings in the aftermath of Auschwitz,[14] painters like Anselm Kiefer and Gerhard Richter have found in painting and its acknowledged incapacity the very possibility of figuring something of their nation's catastrophic history, albeit in vastly different forms and terms.[15] And, from Andy Warhol's single and serial silkscreens of the divisions, deaths, and disasters that marked America in the 1960s to Leon Golub's unflinchingly realist representations of violence and its victims, the stretched canvas has continued to function as a site for historical, if not always also memorial encounter, at once contesting and continuing a painterly tradition that flourished under such foundational figures in a history of modernism as David, Gericault, and Manet.

What I seek to address in this book are those moments in the present when visual practice departs from the convention of what might still be called history painting, and, using representational strategies at once archaic and advanced, makes history its explicit yet also, always, necessarily elusive subject. Although I use the term *history* in discussing this fundamentally historical work of the present, I want to make manifest here the degree to which this book, and, indeed, the art and artists it considers, emerge in the aftermath not just of the "end" of history, which is to say, in the aftermath of a certain Hegelian notion of history as a single, universal, evolutionary social process,[16] but also, in the aftermath of historical events so catastrophic that history as a discursive form may be seen to have reached its limits.[17] That is to say, while I use the term *history,* I mean to embed in my discussion from the outset something of the impossibility of what it means in the present to represent, and in turn, to know *history*. I mean to embed the degree to which history can no longer be understood as straightforwardly referential, but is instead, to invoke here the words of Cathy Caruth, an "oscillation between a *crisis of death* and the correlative *crisis of life:* between the story of the unbearable nature of an event and the story of the un-

bearable nature of its survival."[18] At the same time, when I use the term *history,* I do mean to conjure something of the range of experiences and events that ground our understanding of the past and, in turn, found our relation to the present. These experiences and events are variously individual or collective, local or national, everyday or traumatic and are retrieved or resubmitted to the present through their reconfiguration in representational, or, given the specific concerns of this book, visual form. And it is those visual forms, the particular visual strategies that are used to give the past a place in the present, the aesthetic inheritances that are mobilized to make memory *matter,* that are the structuring subject of the book that follows.

<p style="text-align:center">* * *</p>

If any work of visual art has come to emblematize and influence the cultural activity of memory in the present, it is Maya Lin's 1982 Vietnam Veterans Memorial, conceived and received as a public architectural project of commemoration[19] (figure 2). At once beholden to and yet a departure from high modernist practice, that is, from the visual language of minimalism inaugurated in Frank Stella's eponymous black paintings and solidified in Donald Judd's industrially fabricated boxes, the dark marble surfaces of Lin's monument are buffed to a mirrorlike sheen, the once insistently self-reflexive modernist object now a site not only for literal but for metaphorical reflection. In Lin's spare yet monumental sculptural work, the logic of minimalist seriality is transformed by and into the chronological form of the timeline.[20] The vertical object, the triumphant form of the obelisk, the insistent and hulking presence of the minimalist object, and the historic monument all find themselves razed, recessed, interred in the earth of the nation's capital.

Lin's monument is a formal acknowledgement of the incommensurability of a figurative commemorative practice. The prematurely extinguished lives of soldier after soldier can only be registered as a refusal to represent them visually, their identities acknowledged instead in the unrelenting inscription of name after name upon the unforgiving surface of the marble funereal slabs. These inscriptions bear witness to each individual whose death contributed to the escalating American losses of the Vietnam War, and, as such, the inscriptions rescue the lost bodies of the war dead, if not from the ravages of political and military history, at least from anonymity. Like the trauma to the body politic of the nation that will never be redeemed, the black form of the monu-

FIGURE 2 Maya Lin, *Vietnam Veterans Memorial*, 1982. Photo by the author.

ment cuts into the landscape, at once wound and scar. A wall trans-
formed into a national shrine, a site for reflection, grief and mourning,
if not remembrance, its formal language refashions the "objecthood" of
minimalist sculpture into the form of a "counter-monument," as James
Young has aptly described the antifigurative, antiheroic monuments of
the present.[21]

As a means of refining my discussion of Lin's work, offered here in
anticipation of an ensuing discussion of the visual forms through which
we confront and perhaps even remember something of what we un-
derstand to be history, I want to turn to a piece that counters Lin's in
several crucial respects. It is a project that might be seen, even if only
in the discussion that follows, to stand as a ghostly echo of Lin's black
wall of historical commemoration, at once repeating and revising its
form and its function. The piece is Ann Hamilton's 1997 *welle,* the
weeping wall, the wall of tears, a twenty-two meter by five meter
white wall from which hundreds of tiny droplets of water emerge and
then flow (figure 3). Displayed at P.S. 1 in New York and at the Cartier
Foundation in Paris, the weeping wall was conceived for and incorpo-
rated into the larger installation *bounden* at the Musée d'Art Contem-
porain in Lyons in 1997–98.[22] It has also been repeated, restaged, or

FIGURE 3 Ann Hamilton, *welle* (detail), 1997. Wall drilled with approximately 400 minute holes; water; gravity-fed IV drip system; dimensions variable. Courtesy of Sean Kelly Gallery New York.

reconfigured in such installations as *kaph,* at the Houston Museum of Contemporary Art, 1997–98, in which bourbon pours from the tiny pore-like punctures,[23] and *whitecloth,* at the Aldrich Museum of Contemporary Art in Connecticut (1999), in which the wall is more emphatically a permeable skin that sweats.[24]

What I want to underscore here, before I proceed any further, is that Hamilton's weeping wall is very much part of a larger artistic enterprise dedicated to questions of historical inheritance and, more recently, historical trauma—an artistic enterprise whose strategies and subjects of representation are deeply resonant with those in this book. Nevertheless, when taken in isolation, the piece in question is so powerfully expressive, so powerfully symbolic of something other, particularly when juxtaposed with Lin's monument, that I feel I must include a brief discussion of it here, if only in the interest of articulating and exemplifying the framing thematic concerns of my project, that is, the way in which the operations of memory subtend visual practice in the present.

Where Lin transformed the resistant surface of the modernist object into a resonant historical monument by inscribing, incising, scarring the surface of the minimalist monolith with name after name of war

dead, Hamilton pursued a different form of encounter with the blank face of minimalism, at once puncturing the wall with hundreds of tiny holes and stowing an elaborate system of gravity-fed tubes and valves, not unlike intravenous tubing used in hospitals, behind its surface. If from afar, Hamilton's piece looked like nothing more than a freshly painted, glistening white museum wall or a massive minimalist sculptural object, up close, the wall could be seen to extrude droplets of water, it could be seen to shed tears, to weep, enacting a generalized grief that knew no end. That is, rather than using a set of visual strategies to produce an affective response in its spectator, though certainly such a response is quite possible before such an arresting and evocative work, it is a work that fully embodies or performs affect in an entirely self-enclosed manner, an infinite aqueous loop, reductively, pure affect as visual effect.

Were the Hamilton piece to have been commissioned for or installed in a specific site, as many of her projects are, it would certainly have served as a powerful form of commemorative architecture, emphatically revealing a previously unmarked site to be what Pierre Nora would term a *lieu de mémoire* (a site of memory).[25] But, given its fundamental nonsite-specificity, constructed as it was within multiple and quite various exhibition spaces and contexts, it is not clear for what or for whom it grieves, it is not clear what, or whom, it could be said to mourn. In the radically and repeatedly decontextualized space of the gallery or museum, that white box whose walls its structure repeats, Hamilton's piece performs an act of grief, the shedding of tears, the weeping of the bereaved, but does so in the absence of any identifiable, if irretrievable, referent. A weeping wall, a wailing wall, the blank white wall grieves over a loss that remains unarticulated, unknown, unknowable.

For what, or for whom, does it weep? Hamilton's wall may restage something of the history of the miraculous Christian icon, in which the image was perceived to cry, bleed, or even lactate.[26] Or, given its seeming forsaking of explicitly Christian thematics,[27] Hamilton's punctured wall may repeat, not a history of icons, but of iconoclasm, an iconoclasm imported from a Christian past into a secular present with, among other gestures, Lucio Fontana's attacks upon the late modernist canvas, his abstract pictorial surfaces repeatedly riven with punctures, slashes, and burns. Or, given its nearly invisible puncturing of the visual field, a gesture that allows for the extrusion of water, less than restaging an attack on modernism, on the very surface of the modernist visual field, the minimalist object, Hamilton's weeping wall may instead mourn its own passing, its demise as viable visual form, the resolutely

blank façade but a backdrop for its self-reflexive tears. Or, given its broader and mobile exhibition context, Hamilton's wall of tears may open out beyond the walls of the museum to reflect and collapse, if not also critique our present culture of public and performative grief, a culture in which any loss has the potential to elicit a public outpouring of grief and in which any site has the potential to become a shrine, an impromptu site of mourning, even if not often of remembrance. Or, given the very context of her own body of work, steeped as it is generally in the fugitive qualities of language and history, Hamilton's wall may weep for the victims of history, for all that cannot be represented, for all that cannot be put into language, verbal or visual.

Whatever the presumptive catalyst for or symbolism of its punctures and tears, in its literally mechanical act of grieving, its eternal cycle of repetition, it would seem that Hamilton's piece remains bound, beholden, obliged to perform over and over again in a self-reflexive act of melancholic proportions—a grief that, despite its encompassing title in the Lyons exhibition, *bounden,* knows no bounds. As such, I would suggest that Hamilton's weeping wall powerfully and poignantly exemplifies something of a counterpoint to Lin's monumental work of memory, even if the weeping wall, like much of her work, remains steeped in history, a history of texts, of poetry, of bodies, of locations, of traumas. In Hamilton's piece, the visible signs of mourning, tears, are offered up in relation to a literally lost object. In Hamilton's piece, a disembodied and unbounded grief is performed in a state of perpetuity. Grief is detached from any specified loss and from any concomitant activity of mourning or remembrance. Grief is devoid of any historical ambitions or personal specificity. A blank white wall punctured by tiny holes, the sculptural piece contains nothing other than the mechanical armature, the plastic entrails and viscera, through which it is able to produce tears. The abstracted forms of high modernist practice become the vehicle for the abstracted practice of a mourning that is, in the end, melancholic, producing a sight, that is to say, a display, a spectacle, rather than a site, that is to say, a place, a location, of and for the work of remembrance.

Somewhere in that conceptual ground opened up between the historical specificity of Maya Lin's commemorative wall and the sheer unboundedness of Ann Hamilton's weeping wall rests the work that defines and comprises this book. In other words, if these sculptural works by Maya Lin and Ann Hamilton might stand, albeit very differently, as sites, if not also spectacles, of remembrance, these pieces might also stand as the markers of the boundaries or the limits of the book, the containing walls within which I will house and explore the aesthetic di-

mensions and the ethical capacities of visual objects that pursue the question of memory in the present. From the expressly memorializing to the forthrightly self-reflexive, such contemporary art insistently establishes itself in relation to the work of remembrance. Preoccupied with losses that reach from the broadly historical, to the acutely personal to the strictly theoretical, such art comes to function as a catalyst for and an agent of memory. Such art comes to function as, in other words, what I would consider a contemporary form of mnemonic device.

<center>* * *</center>

It is that question of method, of media, of strategy, that forms the more particular theoretical kernel of the book. For the work I bring together here is generally understood to deploy techniques and technologies that are indexical. In using the term *indexical,* I turn to a concept that is fundamentally linguistic, or semiotic, from C. S. Peirce, to characterize a mode of signification, a mode of making meaning in relation to the world that is predicated on physical contiguity, on material relation, on the trace of touch.[28] But I also turn to a concept that is as well art historical, particularly within the context of the study of postwar art, owing in large part to Rosalind Krauss's influential essays on a set of artistic practices and architectural environments from the 1970s, "Notes on the Index: Part I" and "Notes on the Index: Part II."[29]

Although the classic example of the indexical sign is the footprint, more relevant here is another common example, namely, the death mask. For the death mask is a sculptural object, a memorial object, formed from a mold set upon the very face of the dead. Its anemnetic power derives not just from likeness, but from contact, from touch. Icon and index, the death mask derives its peculiar symbolic power from its founding relation to irredeemable loss. Yet even as the antiquated practice of casting death masks most emphatically literalizes the indexical logic and memorial function of such representational strategies, of physical imprint, so too do the visual technologies of modernity. For photography and cinema are no less beholden to an indexical logic of relation to the evanescent world before the camera.[30] In sum, silhouettes and casts, photography and even film, all of these methods of representation, whose distant origins we encounter in Pliny's mythic tale, are predicated on their contiguous relation to their subjects, their physical relation to the material world.

What is particularly interesting about the artists of memory of the present is the way these artists each pursue something of that indexical

capacity of the image, of the visual field, only to question that capacity, critique that capacity, empty that capacity. What we see, then, in this art of the present is the index as a form rather than a function of representation, the index as a point of reference rather than a referential structure of representation, the index as a vestige rather than a viable means of representation. Kara Walker does not give us actual silhouettes, that is, tracings of bodies in the studio. Instead, she gives us the silhouette as pure form, the silhouette emptied of its functional relation to the real. Krzysztof Wodiczko does not give us the photograph in all its materiality or documentary promise. Instead, he gives us the photograph at one remove, dispersed into the immateriality of its always temporary projection. And Rachel Whiteread does not give us the cast as a kind of architectural double, but instead, takes us inside the structure, gives us something of its inverse, its negation.

But perhaps negation is, at least here, the wrong word. For what Whiteread's work gives us, what each of these artists' work gives us, is not so much negation, as a renunciation of a certain relation to the real. That is, what distinguishes this work of memory from the purely indexical (i.e., that which is predicated on physical relation), or, for that matter, the purely iconic (i.e., that which is predicated on physical resemblance) is the way this work uses its strategies of representation to make clear that such forms are, in the end, just that: forms, conventions, structures. And perhaps that is where the ethics, as well as the aesthetics, of such work may be found, in its self-conscious relation to, yet irredeemable distance from, the historical objects it takes as its subjects.

What do we call the empty index, the impotent index, the index at one remove, the index that is no longer a sign, but instead, pure signifier? Perhaps, as a start, we can address the specific forms that such work takes. Animated monuments and amnesiac apparitions, vaudevillian silhouettes and ghostly processions, sepulchral casts and incinerated architectures, these are some of the postindexical strategies at play, the not-quite indexical structures at work, in this book and, more important, in the deeply memorial, decidedly historical art of the present.[31]

Some number of other artists will also come to mind as I introduce my subject, might seem to fit the parameters of the project as I have defined it, might seem to produce work that is similarly subtended by memory yet equally suspicious of the index, of the trace of touch, as a privileged mode of encounter. However, rather than construct here an encyclopedic account, one that makes its case through sheer numbers and short descriptions, I have chosen instead to develop my argument

through a close analysis of some number of works that I take to be exemplary of these larger trends, impulses, techniques, and thematic preoccupations that may be said to define something of artistic practice in the present.

Thus, that I will not address works as compelling as Marcelo Brodsky's 1997 *Buena Memoria,* a project that makes material and visible by way of a reproduced, enlarged, and annotated eighth-grade class photograph, not only his personal losses and experience of exile, but the 30,000 "disappeared" civilians of Argentina's Dirty War, is not to suggest that his work is not emphatically engaged in such an aesthetic project of memory. Rather, it is to suggest that his work, or such elegiac installations as Zoe Leonard's 1992 *Strange Fruit (for David W.),* or Montien Boonma's 1996 *House of Hope,* or Lee Mingwei's 1998 *The Letter-Writing Project,* or the work of any number of contemporary artists across the globe engaging the problem of history and memory, might be understood through the model of interpretation offered here.

Also, I should make clear that given my prior work on the postwar German artist Anselm Kiefer, I have chosen not to repeat or reproduce the particular questions of history, memory, and visual representation as they take shape in the context of specifically post-Holocaust visual culture.[32] Rather, I simply take Kiefer's negotiation of the aesthetic and ethical dilemma of belatedly representing a traumatic history as part of the larger philosophical and historical context of ontological doubt and epistemological disruption in which the historically-engaged work of the present finds form.

And certainly, there is a significant body of work in addition to Kiefer's that has addressed that traumatic historical legacy, using representational strategies of particular relevance to the project outlined here. For example, the French artist Christian Boltanski, has, like Kiefer, been engaging the historical legacy of the Holocaust for more than three decades, whether in his archival vitrines documenting the life of a fictive (auto) biographical subject or in his shadowy shrines to the presumptive victims of history, conjured up through material artifacts and found photographs.[33] More recently, that is, since the early 1990s, there is the work of Shimon Attie, an American artist whose photographic and filmic projections of archival materials have sutured, if only for the duration of his installations, an absent historical subject with an amnesiac urban present. In Berlin, Dresden, Amsterdam, and Copenhagen, the history of the Holocaust, of deportation, of exile, of emigration, of extermination, returns in the present as ghostly trace, the constitutive absence of the photographic and filmic image fully exploited in his spectral, site-specific work.[34]

There are also a number of artists for whom the historical legacy of the Holocaust is but one subject, a distinguishing moment, rather than a defining focus, of their artistic enterprise. That the artist Rachel Whiteread, for example, whose signature sculptural work I will address at some length in a chapter that follows, was commissioned in the late 1990s to create a Holocaust memorial for the Judenplatz in Vienna, does not demand that her entire oeuvre of casting negative architectural space be understood under the sign of the Holocaust, or as a model for art in the aftermath of historical atrocity, even if its formal strategies would seem to offer themselves up as evocative and appropriate memorial forms.[35]

The importance of such work notwithstanding, rather than continue to discuss what I will not do, let me turn, in the final pages of this introduction, to what I will do. Let me give some sense of the structure and substance of the account that follows—an account that, as I have already suggested, owes its conception to the lamps, shadows, and casts, the antiquated yet somehow also contemporary strategies found in Pliny's legendary tale of visual representation and remembrance. Let me also give some sense of what I mean by the postindexical strategies through which history finds a place, even if not as a fully material trace, in the art of the present.

* * *

The book is organized in three sections, indebted both conceptually and structurally to Pliny's tale. Projection, silhouettes, and casting: the individual sections explore the work of artists whose aesthetic strategies I take to be most revealing of the technique or technology in question. Krzysztof Wodiczko and Tony Oursler, Kara Walker and William Kentridge, Rachel Whiteread and Cornelia Parker, these are some of the artists of memory whose work grounds, if not in some instances, centers, the discussion that follows. The specific artists in question are at once exemplary and individual, their work taken up as much for its ability to represent something of the cultural present as it is for its absolute particularity and specificity. Linked by neither generation nor geography, all of the artists in question have produced a substantial body of work in the 1990s. The book brings them together for the commonalities in their media, their methods, and their ethical relation to the work, and problem, of memory.

The second chapter, organized under the rubric of projection and introduced with a discussion of precinematic technologies of projection, what might be termed an archeology of the cinema, focuses on the

work of an artist who uses photographic and filmic projection as a means of staging an encounter with history and its subjects, that is, its victims and its survivors. And it concludes with a discussion of an artist for whom projection, a term that is also deeply inflected with psycho-analytic meaning, is a means of staging not so much that encounter with history, but instead, the considerable consequences of living without it.

After a discussion of Anthony McCall's 1973 formalist and phenom-enological projection project *Line Describing a Cone,* the second chapter coheres around the work of Krzysztof Wodiczko, a Polish émigré artist based in Cambridge, Massachusetts who, since the 1970s, has made a career of deploying the technologies of photography and film to trans-form, through projection, public spaces into sites of political and, most recently, memorial encounter. From Krakow, to Hiroshima, to Boston, his recent work has brought together the history of monumental archi-tecture with the practice of video, a medium that can be mobilized to serve as a very particular vehicle for testimony, and with that, bearing witness. While taking account of the range of Wodiczko's projects, the chapter is structured around a close reading of one project in particu-lar, namely, his *Bunker Hill Monument Projection* of 1998, a public art project dedicated to a Boston neighborhood, Charlestown, that has been consumed by the losses of gang-related violence and the legacy of murders that remain largely unsolved, even unprosecuted, given the reigning culture of a "code of silence." In the Charlestown project, the video subjects, mothers and siblings, narrate their experiences of los-ing sons and brothers to a seemingly endless cycle of insular violent crime. Filmed from the chest up, these video portraits are also a form of oral history, which, when ultimately projected onto the uppermost portion of the Bunker Hill monument, turned monolith into mega-phone, façade into human face. Animated by voice and image, this monument of heroic patrimony, of local, if not also national identity, was temporarily made to speak, to testify to the crimes to which it, and the community, had born silent witness.

If one of the claims of the chapter is the degree to which the medium of video might be understood here, if not more generally, as an instan-tiation of trauma and its temporality, that is, of belatedness, the coda to the chapter engages the work of an artist who pursues subjects, and with that, subjectivity, in the aftermath of trauma and in the absence of history. That is to say, if Wodiczko produces work that intervenes in an amnesiac public sphere and offers up, even if only belatedly and tem-porarily, the possibility of representing something of a community's history, and allowing for its potential remembrance in and integration into the present, the artist with whom I conclude the chapter produces

work that stages the considerable consequences of existing in the absence of history, in the absence of memory. Taking as its subject the work of the video artist Tony Oursler, the final portion of the chapter posits his amnesiac apparitions, his traumatized subjects, as a symptom of the present. For it is in Oursler's video effigies, lifeless dolls whose blank faces function as unanticipated screens, that the perpetual present of the video loop repeats the very condition of his amnesiac subjects, whose dissociative monologues offer something that we might call not the historical, but the hysterical.[36]

If the shadow haunts the second chapter as a constitutive if utterly immaterial element of the photographic and filmic processes of projection, the third chapter, organized around the rubric of shadows and introduced with a discussion of the technique of the silhouette, pursues that antiquated and spectral form as it is rendered concrete upon the gallery wall. The chapter will focus on the work of Kara Walker, an artist who revives the antiquated process of the silhouette to produce monumental, even panoramic installations that depict a vaudevillian history of antebellum race relations. Concretized in her large-scale pieces is not only the antiquated form of the silhouette, but the equally antiquated though no less enduring stereotypes through which racial identity and racial difference were historically constructed. Walker's revival of this aesthetic technique appears in a moment when the policing techniques of racial profiling stand as a quite literal enactment of what that visual practice makes painfully clear, visible, visual: a nation's history of slavery and its legacy of racial oppression.

As a means of framing the discussion of Walker's silhouettes, the chapter begins with the work of her contemporary, Glenn Ligon, particularly his painterly project, *Profile Series,* 1990–91, and his print series, *Runaways,* 1993. Where *Runaways* appropriates and revises the fugitive slave posters of the mid-nineteenth century as a means of interrogating verbal and visual constructions of race, historical and contemporary, *Profile Series* rests firmly in the present, its journalistic biographies of criminal suspects stenciled across the canvas, darkened words consolidating to form the faint trace of a portrait, a profile that ultimately gives way to a pictorial field of pure abstraction.

Finally, as a means of furthering the discussion of Walker's work, in which the vestigial indexical form of the silhouette is produced in relation to a spectral, monstrous trace of the historical imaginary, the chapter concludes with a discussion of the work of the South African artist William Kentridge. Kentridge is an artist similarly concerned with a national history of racialized oppression, that of apartheid and postapartheid South Africa, and has made particular use of the form of

the shadow. His drawing-based animated films, produced through a technique that may be understood as the successive projection of a series of increasingly palimpsestic drawings, certainly bear a technical relation to the strategies of projection addressed in the preceding chapter. But, given its thematic and historical affinities with Walker's work, the chapter will specifically address one filmic work that is distinctive in his ouevre for its explicit mobilization of the shadow as a means of engaging something of his nation's political history, namely, *Shadow Procession* of 1999. [37]

The fourth chapter of the book, organized by the rubric of casts, explores those works that take up aesthetic processes that depend upon and yet depart from the logic of the sculptural cast, that maintain a relation to the material body in the world yet produce that relation in the negative, in suspension, voiding something of the practical and conceptual logic of that sculptural process. Framed in part by a discussion of a particular aspect of the casting process, namely, the tradition of the death mask, the chapter examines the work of Rachel Whiteread, whose sepulchral castings give material presence not to actual buildings or fixtures, but to their interiors, to their empty places, to their negative spaces, that is, to the absences and unmarked spaces within the domestic domain.

As Whiteread's work has grown more massive in scale, moving from casts of bathtubs, sinks and closets to those of an entire room and even a house, her work has come to stand as a perhaps unwitting monument to a certain history of British domestic objects and vernacular architecture, even as those forms persist in the present. More specifically, it has come to function, at least most explicitly in her project *House,* created in 1993 and destroyed in 1994, as a form of memorial to older working class neighborhoods of London whose communities are transformed by waves of immigration and whose social, if not also, architectural infrastructure is giving way to the forces of urban decay, renewal, and gentrification. As explored through a discussion of Jane and Louise Wilson's neo-Gothic cinematic treatment of an abandoned Victorian house, their 1995 *Crawl Space,* Whiteread's work gives back, if only as ghostly, uncanny, *unheimlich*—literally translated as unhomelike trace—the immaterial essence of a house that will never again be a home.

In order to understand the particular relation Whiteread's work establishes to domestic space, the chapter looks to the work of several other contemporary artists whose work addresses the space, be it remembered or fictive, of the home, foremost among them Maria Elena Gonzalez, whose cast and sculpted work not only shares Whiteread's

concern with domestic architectural space, but shares something of her method, namely, variations on the index. Gonzalez's otherwise minimalist "magic carpets" offer the trace of dwellings present and past, from the cast floor plans and footprints of apartments in public housing projects to those of her familial homes in Cuba. The chapter looks as well, even if only briefly, at the work of Toba Khedoori and Do-Ho Suh, whose work helps define the parameters of such domestic representations, from Khedoori's mobilization of the axonometric language of architectural drafting to Suh's deeply personal re-creations in diaphanous fabric of his family's home in Korea.

The chapter also looks at the photographs of James Casebere and does so for the simple if not immediately evident fact that his photographs are taken not of actual buildings but of architectural models. That is, his large color photographs derive not from their relation to buildings in the world, but buildings as they are imagined or remembered in the studio, materialized in his exacting models and dioramas of buildings never to be realized. In his most recent work, much of which conjures historically resonant architectural types, even if not sites, his images attend to tunnels and hallways, points of passage and enclosure within the architectural interior. Always unpopulated, often flooded with water or raked with light, and fully evacuated of even their fictive pasts, Casebere's photographs, in an emphatic emptying of their presumptive status as document, produce a visual trace of a building, an interior, an urban space, that never was. It is an architecture haunted not by its past, but precisely by a fundamental absence of presence.

Finally, as a counterpoint to Whiteread's casting, if not also Gonzalez's footprints and floor plans and Casebere's photographs of buildings that never were and never will be, the chapter concludes with a discussion of the work of Whiteread's compatriot, Cornelia Parker. In such sculptural installations as *Cold Dark Matter: An Exploded View,* 1991 and *Mass (Colder Darker Matter),* 1997, Parker salvaged the remains of buildings consumed by fire, charred pieces suspended from floor to ceiling by taut wire — yet another means of exploring the negative capacity of sculptural form as it accrues around the empty center that is the lost object of domestic architectures past.

* * *

It is out of this set of fundamentally architectural comparisons and juxtapositions that the chapter and book conclude, having mined the various postindexical strategies evinced in the work of memory in the pres-

ent. Projections, silhouettes, and casts, these foundational representational techniques and technologies return in the present as a means of figuring, even if only obliquely, an ever elusive past. And if we look, if only briefly here, beyond the works of contemporary art addressed in this study to the larger cultural moment, it becomes clear that the index, even if emptied of its semiotic function, emerges as a compelling form for concretizing and commemorating loss, for marking and memorializing absence.

For Art Spiegelman, the shadow, that quintessential index of the body, of presence and proximity, is invoked only to convey an irredeemable absence and irrevocable break, as the title of his graphic response to 9/11, *In the Shadow of No Towers,* makes painfully, poignantly clear. Already an utterly immaterial form, the semblance of a sign that is nothing more than a disturbance in the visual field, an occlusion of light, Spiegelman's shadow is a shadow in the absence of a body, which is to say, a shadow that is only ideational, fully spectral. For, of course, there is no shadow without the towers. And there are, after the events of the morning of September 11, 2001, no towers. Spiegelman's shadow fully gives way to its essential nonessence; it is dematerialized into the void that it always already was, emerging instead as pure signifier, a metaphoric means of conjuring the experience of living and working in lower Manhattan in the aftermath of witnessing the collapse of the twin towers. For Spiegelman, the events of 9/11 cast an enormous shadow, even if they leave no material, visible trace. And his book, part graphic novel, part history of newspaper comics, is a means of addressing, if not redressing, that void.

Similarly, Michael Arad's proposal for the World Trade Center memorial competition, *Reflecting Absence* (figure 4) takes its forms from the semiotic realm of the index, as did many of the 5,201 entries that sought to defy the codes of traditional memorial architecture. *Garden of Lights, Votives in Suspension, Lower Waters, Suspending Memory, Inversion of Light,* and *Passages of Light: The Memorial Cloud,* light, vapor and water were the consistent elements of designs that sought to mark a space for memory. With instantiations of fluidity and evanescence trumping the solidity of traditional monumental form, so too did abstraction eclipse figuration, the symbolic displace the literal, the index disrupt the icon. Even *Dual Memory,* which distinguished itself from the other finalists for its insistence upon figuration, still relied on the indexical, its shifting photographic images and textual accounts of the victims all projected onto transparent scrims of screen.

Arad's commemorative scheme demarcates the outlines of the bases of Minoru Yamasaki's twin towers with two pool-filled voids, com-

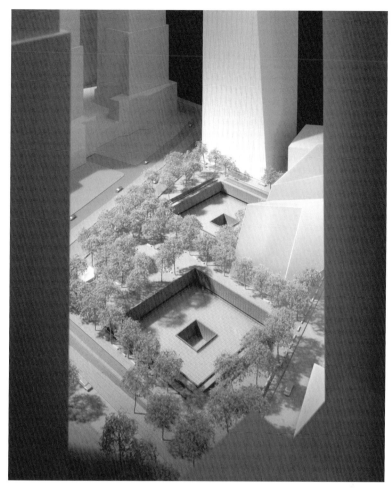

FIGURE 4 Michael Arad, *Reflecting Absence,* model for the World Trade Center Memorial, 2004. Courtesy of Lower Manhattan Development Corporation.

memorative design explicitly deploying the language and logic of the silhouette. Walls of water giving way to reflecting pools, the edges of each etch onto the landscape the reconstituted architectural footprints of the lost object, the lost objects, the twin towers, uncanny doubles even at their moment of creation and construction. Negative space concretized into memorial architectural form, Arad's proposal attempts to address loss, to express loss, through the monumentalization of and insistence upon absence.[38]

Arad's memorial proposal counters and inverts the almost redemptive forms of *A Tribute of Light,* which, on March 11, 2002, repeating the form of Yamasaki's twin towers in two intense, ascending beams, temporarily restored the skyline of lower Manhattan by making visible

again, even if only as spectral trace, the irredeemably absent architecture. In contradistinction, Arad's memorial is recessed in the earth, two depressed voids that continue the vector of downward motion of the collapse of the twin towers, the desperate plunge that was the descent of the "falling man." A gravitational movement whose trajectory and force is echoed in the waterfall that cascades down the surfaces of the recessed walls, the perpetual cycle of water also repeats something of the structure of the horrifying video loop that blocked, displaced or simply became our memory of the event, representation replacing the real.[39]

In formal terms, it may be said that Arad's memorial proposal reprises or echoes certain crucial aspects of Daniel Libeskind's initial architectural plan for the World Trade Center. Though now much modified, Libeskind's plan captured the imagination of its judges and a broader public in part for the symbolism of its soaring architectural form, the unfortunately named and sized 1776 foot Freedom Tower, a building conceived to condense and restore to the skyline of lower Manhattan the monumental presence of the twin towers, while echoing and emblematizing all that is signified by the torch held aloft by the Statue of Liberty. Its appeal lay as well in its insistence on maintaining and foregrounding the exposed subterranean structure of the World Trade Center, the retaining wall that had held back the waters of the Hudson. Its surface marked and scarred by the traces of the site and its destruction, an architectural remainder and reminder, at once survivor and mute witness, Libeskind's exposed slurry wall managed also to repeat, or at least recall in its minimalist form and recessional relation to its site, something of the visual language and symbolism of Lin's Vietnam Veterans Memorial, that monumental form that in its departure from tradition has come to define a new tradition of memorial architecture in the present.

But, unlike Libeskind's inclusion of the surviving slurry wall, Arad's design provides not so much a trace of the lost object, or in this case, objects, namely the twin towers and all they represented, but rather, an illusion of their tracing. Unlike Libeskind's slurry wall, in Arad's design there is no relation beyond the symbolic to the lost towers. Even as Arad's walls of water take and map as their site the former footprints of the twin towers, demarcating as massive voids the areas from which the twin towers once rose, they are not, of course, actual architectural footprints. They are, instead, something like an architectural site plan grafted belatedly onto the landscape of death and destruction. Collapsed and cleared away, the towers left no footprints, no markers, no

imprint, no index. In the memorial landscape that will be the new World Trade Center, save the slurry wall, which may or may not, in the end, remain, there will be no trace of what once was. Unlike an actual footprint, an imprint or outline that bears the trace of what stood above it, of the massive buildings that once pressed their weight upon the surface of the earth, of the looming towers that once rose above the streets of lower Manhattan, Arad's memorial footprints, his walls of water, his monumental silhouettes, are not an actual trace of what once rose above that now hallowed ground. Their imprint is only imagined, a means of belatedly marking, memorializing that which remains irredeemably absent.[40]

<center>*　　*　　*</center>

In the increasingly attenuated interval between events and their monumental public commemoration, there exists a relation of temporal proximity that would seem to deny in its virtual immediacy the sedimentation and assimilation of loss that comes with the passage of time, with the work of mourning and memory. An architectural competition to rebuild the World Trade Center was announced as rubble and remains were still being cleared from the site. Arad's memorial design was submitted and selected barely two years after 9/11. And yet, even as that acceleration of process compresses a certain notion of historical understanding, as the plans of Arad and others suggest, that temporal collapse may not foreclose the possibility of memorial form, and with that, remembrance.

For if, as I have suggested, Pliny's tale is not just a story about the origins of painting, but is as well, a story about loss and the strategies of remembrance it produces in the visual field, it is useful here. An anticipatory gesture, the Corinthian potter's daughter traces a shadow, draws a silhouette, before her lover has left, preparing herself for the time to come, when all she will have is her memory. As a mnemonic device, the silhouette she traces does not give her a fully realized image, a replacement or simulacrum of her lover. Instead, it gives her an outline, a marker, a designated space in which to remember. The drawing does not do it for her. It merely establishes the possibility.

As the imperatives of commemoration continue to weigh upon the present, memorial competitions and their resolutions increasingly defining not only public space, but public discourse, it remains to be seen what kinds of aesthetic and architectural strategies will continue to capture the public imagination. But whatever the representational tech-

niques and technologies, whatever the methods and materials, it will be, at least in part, within the realm of the visual that strategies will be found to give form to all that can, and moreover, *cannot* be represented. And as the historical continues to recede from the present, as contemporary events continue to defy and yet demand representation, it will remain the ongoing aesthetic and ethical challenge of the visual to find the means to make memory matter.

2 WHEN MEMORY SPEAKS

A Monument Bears Witness

. . . his face, thrown by the lamp

PLINY THE ELDER

In 1973, Anthony McCall's *Line Describing a Cone* presented the beam of light from a film projector as sculptural form, minimalist object dematerialized (figure 5). At its most basic, the piece was nothing more than an exercise in geometry, the methodical formation, through simple animation techniques, of a white gouache circle on black paper. Of course, conceived in a context informed as much by experimental filmmaking as by minimalist, conceptual, and performance art, McCall's piece was also an exercise in phenomenology. For it insisted upon a recognition of the distance that divides the apparatus of projection from the cinematic screen. It drew attention to the space that separates the source and site of projection. And, perhaps most important, it made concrete, even if only as luminous, transparent volume, the conical shape of projected light that is the transmission of the cinematic image.[1]

As McCall himself described the project, in a statement to the judges of the Fifth International Experimental Film Competition, in Belgium in 1974:

> *Line Describing a Cone* is what I term a solid light film. It deals with the projected light beam itself, rather than treating the light beam as a mere carrier of coded information, which is decoded when it strikes a flat surface.
>
> The viewer watches the film by standing with his or her back toward what would normally be the screen, and looking along the beam toward the projector itself. The film begins as a coherent pencil of light, like a laser beam, and develops through thirty minutes into a complete, hollow cone.
>
> *Line Describing a Cone* deals with one of the irreducible, necessary conditions of film: projected light.[2]

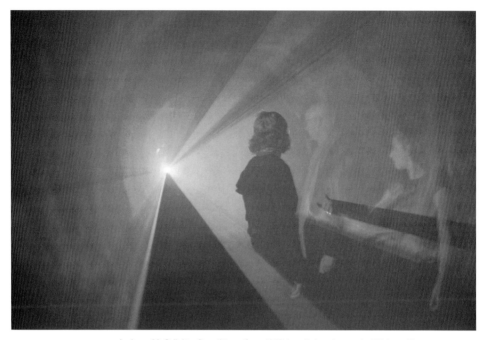

FIGURE 5 Anthony McCall, *Line Describing a Cone*, 1973. Installation view at the Whitney Museum of American Art exhibition "Into the Light: The Projected Image in American Art 1964–1977," 2002. Photograph © Henry Graber, 2002. Courtesy of Anthony McCall.

Even as *Line Describing a Cone* evacuated the cinematic experience of everything but the light through which it was constituted, McCall's piece was far from empty. For it was also an exercise in history, a history of visuality, a history of optics, a history of cinema. That is to say, McCall's piece produced and staged, in its concentrated beam of light, a situation of encounter with the very category of projection, that enabling technology of the cinema.

Concave mirror, magnifying lens, illuminating light source, the fundamental technical elements dramatized in McCall's work of pure projection were also the essential elements in the optical device known as the magic lantern. A seventeenth century invention, the magic lantern used transparent plates and a candle as light source to project scientific demonstrations and phantasmagoric spectacles onto the surfaces of walls or scrims of fabric. By the late eighteenth century, the magic lantern emerged from darkened rooms of the home or the laboratory into the public space of the theater. And over the course of the nineteenth century, the magic lantern was succeeded by such projective instruments as the phenakistiscope and the stroboscope, the zoetrope and the praxinoscope, whose pursuit of the illusion of movement may be understood, particularly when coupled with a history of the emergence

of photography, and such important achievements as Eadweard Muybridge's motion studies, as forging the foundations of cinema.[3]

For all of the successive developments in the technologies of cinema, one thing remains constant, if not "irreducible." As McCall's piece makes palpably clear, there would be no image on the screen were it not for the basic principle of projection, the throwing of an image, by candle, lamp, or bulb, the casting of a shadow. From the moment of the (mythic) origins of the projected image, whether we look to Pliny or Plato, it was the light source, lamp or fire, that cast a shadow upon the wall, that provided a founding paradigm for the image on the screen. That is, it was a light source that would allow for the production and refinement of the technologies of the cinema.

At the same time, it was a light source that transformed the image as index into the image as illusion, photograph into phantom. For even as that projected image maintained its properties of likeness, it was also, always, a mere semblance. That is to say, even as the properties of reflected, magnified, and focused light allowed the projected cinematic image to reproduce its subject with all the mimetic fullness of the photographic image upon which it was predicated and through which it was produced, that cinematic image was and remains constituted in and as the play of light and darkness. In its projection, the indexicality of the photographic image gives way to displacement and dispersal, less rematerialized than dematerialized, a constellation of fugitive shadows.

<p align="center">* * *</p>

To the history of (cinematic) projection may be added the history of video. Certainly, in ways far more manifest than McCall's 1973 piece, much of Tony Oursler's work has come to both enact and thematize its relation, as video, to precinematic technologies of projection. Where his video installation *Optics* (1999), replete with camera obscura, stages an encounter with the physics and metaphysics of early technologies of visual representation, his accompanying text, titled "I hate the dark, I love the light," digs deeper, charting a history of specular devices and discoveries that date to the fifth century before the common era. A timeline of sorts, the text expands the parameters of projective technologies to include not only the ocular, but the occult, suggesting the ways in which the dematerialized image in the darkened chamber was not simply an early form of visual spectacle, but also, and perhaps always, a kind of specter.[4]

Of course, video was not, and is not, a purely projective medium. First screened in the gallery on television monitors, if not also, in its

early years, aired on television on local public-access channels, video simultaneously privatized and democratized the production and reception of moving images.[5] But if a televisual model of transmission was its predominant exhibition format during the 1960s and 1970s, by the 1980s and 1990s, technological improvements allowed artists to use large-scale, high-definition video projection as a means of display, monitor supplanted by screen.[6] Whether reproducing aspects of the movie theater when projected upon the white walls of the museum gallery, or mobilizing elements of the drive-in when projected on building façades, with the advent of new technologies of projection, video became cinematic in its form of visual spectacle, its images similarly monumentalized, and dematerialized, on the various surfaces it took for its screens.

The range of such work of video projection is vast. In addition to Oursler, artists such as Bruce Nauman, Bill Viola, Douglas Gordon, Shirin Neshat, Pipilotti Rist, Jane and Louise Wilson, and Krzysztof Wodiczko have consistently employed technologies of projection in their work. But if each has explored aspects of projection, whether splitting or doubling the image, varying speed or scale, orchestrating multiple projectors, or mobilizing unconventional or unanticipated surfaces as screens, only one, namely, Krzysztof Wodiczko, has persistently and deliberately used projection as a means of structuring an encounter with history, which is, in the end, the more particular concern of this chapter. Which is not to say that Bill Viola does not invoke, by way of his video portraits and tableaux, a history of art history, or that Douglas Gordon does not address, by way of his repetitions and appropriations, a history of the cinema, or that Jane and Louise Wilson do not engage, by way of its ruins and remains, a history of the former Soviet Union and the countries of the Eastern Bloc.

But none uses projection to produce the kinds of emphatically memorial works that have come to characterize Wodiczko's practice. From the outset overtly political, Wodiczko's projects have become increasingly, or additionally, historical in their ambitions. First using still images and a slide projector, later turning to the possibilities of the moving image and video projector, Wodiczko has made a career of using the technology of projection to transform architectural façades into monumental screens.[7] City halls and houses of parliament, courthouses and embassies, museums and monuments, each has been mobilized as a site of projection, with swastikas, Pershing 2 missiles, guns, candles, microphones, chains, crutches, boots, hands, and faces illuminating and inflecting their surfaces.

What makes Wodiczko's video installations particularly interesting is not only the ways in which they extend his use of the technology of

projection. Nor does their interest lie simply in the ways in which they continue his use of a symbolic register of representation, generally deploying synecdochic strategies as a means of figuring without fully depicting his subjects. (For example, in all but one of his video projections, it is the hands of his subjects, rather than their faces, that appear on a given urban edifice.) What makes them specifically interesting for my purposes here is that such representational forms, that is, video projection and symbolic representation, come together with another mode of representation, namely, oral testimony. And, even if it might seem that this introduction of voice, of narration, of words shifts the parameters of his work, I would suggest that the presence of testimony in fact secures something of their very status as video, as video projection. For in offering up testimony as representational form, Wodiczko's video projections instantiate something of what I would suggest is video's ontology, namely, the act of bearing witness, in all of the ethical complexity and incommensurability of that juridical and historical project.

*　　*　　*

From the Latin, *videre,* to see, the word video is an intentional echo of its technological predecessor and analogue, audio, based as it is in magnetic technologies of recording. But even more, its naming denotes a visual form that, unlike any other visual medium, is also an action, a declaration: I see. That action, that declaration, may or may not be the ontological condition of the medium, even if it is its literal definition. Certainly, to the extent that Rosalind Krauss's 1976 article "Video: The Aesthetics of Narcissism" continues to set the theoretical terms through which we understand its status, video has been understood to declare, through the splitting and doubling of the mirror-reflection of synchronous feedback, "I am."[8] Writes Krauss, of Vito Acconci's 1971 *Centers,* posing a question that she will set out to answer over the course of the essay, "In that image of self-regard is configured a narcissism so endemic to works of video that I find myself wanting to generalize it as *the* condition of the entire genre. Yet, what would it mean to say, 'The medium of video is narcissism?'"[9]

Of course, such a narcissistic impulse to confirm one's presence is mired in doubt, which would suggest that such early video work does not so much state, "I am," as instead ask the question, "I am . . . am I not?" Demanding of its audience an act of witness that is an act of affirmation, video as medium articulates a message that is as philosophical at it is psychological. Moreover, in that act of address to its audience, it is also, necessarily, social. And it is this social ontology of video that

David Joselit pursues, when, writing in the aftermath of such video exhibitions as the Whitney's *Into the Light* and P.S. 1's *Loop,* he suggests another ontology of video. In an explicit return to the matter and material of the alternative journal *Radical Software,* 1970–74, Joselit insists upon video as a thoroughly social act, a form that "interpellates the spectator as an object and an other," a means of talking back.[10]

Building on Joselit's insight, I want to suggest that if video is a means of talking back, of address, it can have something very particular to say. Video, like its other, related technological predecessors, film and photography, relies on the fact (and fiction) of indexicality, on the relation of the final form to the physical presence of a subject before the lens of the camera.[11] It asks that we bear witness to its act of witness. Video, like its predecessors, photography and film, also relies on the presumptive presence of a subject behind the camera lens, a subject who, by proxy or not, sees. (Video) camera as prosthetic eye, it is the (video) camera that sees. It is the (video) camera, it could then be said, that bears (prosthetic) witness.[12] For when that recorded video image is played back, not in the instantaneity of real time, but in the deferred time of its screening, the time of its *projection,* video performs something other than what it literally proclaims. That is, in the belatedness of its projection, even as video states, as medium, "I see," video as visual spectacle, as visual specter, testifies to the act of having seen, video thus effectively avers and avows, "I saw."[13]

What, then, of a video project, a video *projection,* that instantiates such a condition, that manifestly proclaims its function as an act of bearing witness, as an act, in other words, of having seen? Such is the condition, the declaration, of Krzysztof Wodiczko's *Bunker Hill Monument Project,* a site-specific video installation that takes commemoration as both its challenge and its charge (figure 6). The project, part of the Institute of Contemporary Art of Boston's public art initiative, *Let Freedom Ring,* ran for three consecutive nights in late September of 1998, transforming the southern façade of Charlestown's Bunker Hill monument into a vehicle for testimony, a screen of memory.[14]

For the project, the mothers and brothers of young men, victims of an endless cycle of insular urban violence, spoke of familial losses, their faces and voices animating the petrified façade of the monumental obelisk and its immediate environs. Wodiczko himself described the project as follows:

> For several hours on three consecutive evenings in September the southern face of the Bunker Hill Monument in Charlestown is illuminated with video image projections. These projections add motion im-

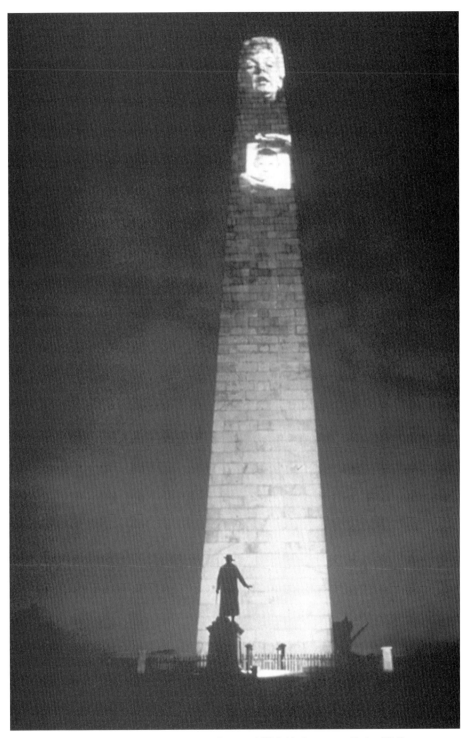

FIGURE 6 Krzysztof Wodiczko, *Bunker Hill Monument Projection*, 1998. Public Projection at Bunker Hill Monument, Boston, Massachusetts. © Krzysztof Wodiczko. Courtesy of Galerie Lelong, New York.

ages of the human face, human gestures and sounds of the human voice to the abstract shape of the obelisk. It becomes the gigantic human figure of a private citizen, and actual person—a Charlestown or South Boston resident—who speaks freely and boldly of her or his personal experiences and struggles for "life, liberty, and the pursuit of happiness" and for "justice for all." This historic monument, dedicated to the heroes of a Revolutionary War battle, becomes a contemporary memorial to the present-day heroes or heroines who continue another battle on the same (sacred) ground. This battle against tyranny and oppression continues still, inflicted now by murderous and unpunished urban violence and perpetuated by speechlessness and silence, imposed from without and from within. For three evenings, the Bunker Hill monument asserts its First Amendment rights and speaks of what it has seen and of what it has heard.[15]

Wodiczko characterizes the project in several useful ways. First and foremost, he specifies its location, structurally and geographically, on the face of the Bunker Hill monument, the most famous, enduring and visible structure in what is otherwise presently known as one of Boston's most impoverished and crime-ridden neighborhoods. Second, he explains the execution and resulting visual presence of the project, conveying something of the visual impact of transforming the uppermost portion of the monument into a looming anthropomorphic video screen, a towering talking head. Third, he provides access to its inspiration, namely, the language and logic of the United States Constitution, conveying something of its social and political ambitions, a broadly utopian vision that informs both this project and the vast majority of Wodiczko's extensive body of work. Fourth, and finally, he ends by describing the project as a work of testimony, as an act of giving voice to that which has been silenced. And in that closing observation, he demonstrates the degree to which this work, much like his video work more generally, is shaped by the ethical imperative to bear witness.

* * *

Best known for the revolutionary monument that adorns its highest point and commemorates a lost battle that nevertheless came to signify the triumphantly rebellious American spirit that would ultimately defeat the British, Charlestown, Massachusetts became known in the next century as Boston's most Irish neighborhood, and in the following century, as an industrial, and then, postindustrial slum. Over the course of

the twentieth century, what had been a working-class neighborhood supported by the labor of longshoremen and factory and Navy Yard workers, was by the 1960s, an enclave severely weakened by unemployment, gang violence, drugs and alcoholism. Boston's busing crisis of the 1970s only further fractured the social fabric of the still insular Irish-Catholic neighborhood.[16]

By 1998, when Wodiczko, a professor at nearby MIT, set out to do a project that, like much of his recent work, would focus on the problems of immigrants and the homeless in different neighborhoods in the city, he discovered something very particular about Charlestown. Not only did the residents of Charlestown, a mere one-mile square neighborhood, consistently experience one of the highest murder rates in Boston. Its residents also lived under a "code of silence" that left the majority of those murders unsolved. Thus, the project that he came to conceive and execute was one that sought to redress that silence.

Like his earlier video projection in Krakow in 1996 and like his subsequent video projection in Hiroshima in 1999, the Bunker Hill project combined the methods and imperatives of oral history with the techniques and technologies of video recording and projection. All three projects were linked not only by their investigative historical methods and their projective visual technologies, but by their consistent interest in the voices of victims. In Krakow, Wodiczko focused on the survivors of domestic abuse, who, prior to his intervention, had suffered in silence. Shooting only their hands, a means of preserving both their anonymity and dignity, Wodiczko made their voices and stories heard. Gesticulating, playing with a wedding ring, offering a candle, wringing a rag, holding a cigarette, peeling a potato, pulling the petals off a flower, the victimized women of Krakow temporarily occupied a position of centrality and authority, their partial and protected images projected across the tower of the fourteenth-century city hall. In Hiroshima, Wodiczko worked with the survivors of the devastating bombing, projecting their testimony on the base of the A-bomb dome that, like his interview subjects, had withstood, even if only as a ruined shell of its former self, the historical catastrophe. Again, as in Krakow, hands stand in for the speaking subject, shielding the subject from the gaze of both the camera and the spectator. And these hands, whether holding handkerchiefs, padlocks or simply each other, are doubled and dispersed in their reflection and refraction in the river that flows beneath them.

In Charlestown, Wodiczko sought to restore voice and visibility to those families whose losses had been compounded by their fundamental inability to seek justice for the murders of the sons and brothers, the

possibility of testimony lost to a reigning culture of silence. Those murders, and that culture of silence, had only just received a degree of national attention, even if only short lived, with the release of Ted Demme's 1998 film *Monument Avenue*.[17] Critically received as an Irish-American *Mean Streets*, the film was indebted not only to Martin Scorcese but to the more immediate influence of the wave of films that followed on the heels of John Singleton's 1991 *Boyz 'N the Hood*. Like many of the "hood" movies that preceded it, for example Red Hook's *Straight out of Brooklyn*, Providence's *Federal Hill* or Echo Park's *Mi Vida Loca*, *Monument Avenue* was as much about the ethnic urban neighborhood in which it was set as it was about the drama. That is, as much as *Monument Avenue* depicted a circle of childhood friends, linked not only by their shared past but by their shared petty gangster present, it also portrayed an Irish-Catholic neighborhood, whose integrity was threatened not only by the endless cycle of gang violence, but by dual forces of immigration and gentrification.

From the establishing shot, it is the Bunker Hill Monument that defines the location of the film, the eponymous Monument Avenue, the street that runs up the hill to the monument's base. With the exception of one scene involving a car theft, the film takes place entirely within the neighborhood of Charlestown, a peninsula bounded not only by the Charles and Mystic Rivers, but by the steel stanchions of the elevated rail and the ramps and roadways of Interstate 93. It is in that neighborhood, defined by its narrow streets, its many bars, its hockey rinks, and its signature brick townhouses and clapboard houses, that a moviegoing public comes to learn of another defining characteristic, the "code of silence" that consigns its inhabitants to an unrelenting cycle of unsolved murders and unending grief. Though that public, as viewing audience, bears witness to a series of murders, it is as unable to testify as the filmic characters who witness these crimes. Its constraint, however, remains purely cinematic. The characters' inability is a product of a deeply ingrained code of behavior, one founded in equal parts fear, suspicion, and loyalty.

It is this code of behavior, this "code of silence," that Wodiczko also takes as the point of departure for his project, a means of redressing what he terms the "double victimization" of the victims' families, who lose both a son and the possibility of justice.[18] With its cornerstone laid by the Marquis de Lafayette himself, the Bunker Hill monument not only commemorates a historic battle and its losses, but concretizes and represents something of the ideals over which that revolutionary battle for freedom had been waged. For Wodiczko, the video project was in part a means of achieving that freedom, that liberty, ideals that he came

to learn were sorely lacking in the day to day lives of the neighborhood's present citizens. In videotaping the surviving relatives of Charlestown's murdered sons and projecting portions of those interviews before a gathered public, Wodiczko transformed the petrified historical monument into a living, speaking, utterly contemporary form, an animated memorial to present injustice.[19] He made the monument a megaphone, turned its façade into a human face, changed its sculptural base into a pedestal from which the words of its citizens might be heard. In sum, Wodiczko sought with the medium of video projection to give voice to that which had not been spoken, to realize in aesthetic form his founding condition and proposition, "if only this monument could speak."[20]

Of course, Wodiczko's project was not the first time that Charlestown's citizens were afforded a public forum for their grieving voices, even if, when shown the video of the Krakow City Hall project, they were inspired to participate in a similar situation to give voice to their own experiences. That he was even aware of the murder rate in Charlestown is a tribute to the work of a group of women, mothers, who founded the Charlestown After Murder Program. Based within the community, the program was committed to speaking out. The Charlestown mothers built ties to grieving mothers in other Boston neighborhoods, participated in gun buyback programs and pressured law enforcement, and in turn, the media, to pay more attention to the murders in their community.[21] Perhaps most relevant to the realization and execution of Wodiczko's project, however, was the very fact that they organized an annual vigil and invited their neighbors to speak. And it is these same mothers, and brothers, who first stepped up to the altar in St. Catherine's Church in Charlestown, who form the core of Wodiczko's project, a project that, like the vigil, is at once a work of memorial and activism.

* * *

The projection runs for nineteen minutes, cutting back and forth among the five participants, three mothers and two brothers. The participants are filmed from the chest up, so that we might glimpse the candle or photograph they hold as they offer their testimonials to the camera. Forgoing the anonymity of their predecessors in Krakow, they show their faces, and, in most instances, speak their names. Clasped in the hands of these mourning mothers and bereaved brothers, each of whom offers memorial testimony, the candles and photographs function as additional registers of remembrance. Rather than stand in for the speaking subjects, these items underscore the commemorative na-

ture of the endeavor in which they participate. Central and repeated elements in cultural practices of memory that range from vigils and shrines to funerary monuments and family albums, the candles and photographs stand as much for these rituals and sites of remembrance as they do for the individual young men they seek to honor and remember. Attributes that reinforce the memorial testimony each subject offers, the candles and photographs are also a reminder of a set of visual strategies, a set of visual technologies, with which their testimony is registered and through which their testimony will be witnessed. That is, candle and photograph, light and image, projection and representation, each form references at once its relation to medium and its relation to modes of memory. And that relation to both medium and method is quite particular. Recorded not by a historian but by an artist and destined not for an archive but for an audience, their testimony and their memorial offerings are directed toward a video camera but intended for a public that will bear witness to their visages and words in a temporary installation, a video projection, a spectral display of illumination and image, a play of light and shadow.

One participant, Sandy King, a cofounder of the Charlestown After Murder Program, lost not one, but two sons to the culture of violence. In her testimony, she at one point explicitly repeats the language of the vigil:

> This eternal flame burns in the memory of Christopher King, age twenty, murdered on August 26, 1986. It burns in the memory of Jay King, murdered on April 7, 1991, age twenty-seven. It burns in memory of Adam, age twenty-one murdered on July 26, 1991. This flame is in memory of James Boyden the third, James Boyden the fourth, Patrick, John Fitzpatrick, and so many other people who lost their lives in Charlestown.[22]

Against King's explicit repetition of the codes of memorial as performed in the context of the vigil, there emerges in the testimonials of Wodiczko's subjects another kind of speech, a speech that is pointedly directed against the codes of silence. Such speech may be found in the testimony of Pam Enos, another cofounder of the Charlestown program. Her twenty-one-year-old son Adam, named above by King, was murdered in Charlestown, as Enos points out in an observation that insists upon the specificity of site as a means of linking past to present, "right down the street, down the hill," just down the hill from where a crowd of spectators gathers to hear her words. In her statement, Enos also invokes the code of silence, the failure to testify:

There were people there who saw Adam, people who were his friends, and for one reason or another they don't want to come and testify. I know that they were not responsible, but I wish they would think of this one thing—this is that they didn't choose for it to happen, but they choose what will happen from that point on. And they too have to think of their freedom, and they too have to think of their loved ones. What they would want for them.

A call to conscience from a mother, it is nevertheless the remaining brothers who speak out most explicitly against the code of silence, one in which they, like their lost siblings, were raised and acculturated.

One participant, a young man named Steven, speaks of the climate of distrust and harassment he has experienced at the hands of local police since he was a child, beginning with his witnessing the arrest of his own father. Steven concludes his statement with the following plea to the police:

> And a cop rolls by slow, and he's starin' at my eyes like I'm doing something wrong, or I *had* to be doing something wrong, or just, he's *waitin'* for me to do something . . . I mean, how do you know I wasn't just comin' home from supporting my family? How do you just come up and think that I gotta be doin' something bad. Talk about Officer Friendly. *Be* Officer Friendly. Wave to me. Drive by. Smile. Wave. Say: How was your day? Then I won't look at you so differently. I'll ask *you,* how was your day. You know? And maybe have a better outlook towards you. I mean, we could talk. And break that chain of the code of silence.

The other male participant, the writer and community activist Michael MacDonald, author of the 1999 memoir, *All Souls: A Family Story from Southie,* echoes Steven's plea, even if his words are tinged with the kind of resignation that pervades Demme's film.[23] He is the one participant in Wodiczko's project to come not from Charlestown but from South Boston, another predominantly Irish-Catholic neighborhood, former home of the infamous mob boss and FBI informant Whitey Bulger and similarly plagued by deeply entrenched poverty and a desperate cycle of lawless justice. After recounting the deaths of two of his brothers, Davey and Frank, MacDonald ends his video testimony with the following lines, whose indictment of the "code of silence" is all the more severe and unanswerable for the economy of its means and the emotional restraint of its delivery:

> When I was seventeen, my brother Kevin was found hanging in a prison cell in Bridgewater. He was being worked on by police, who wanted

him to give information about what he knew about organized crime in South Boston. The gangsters knew that he knew too much, and I believe that they killed him. It was made to look like a suicide, and it was never investigated. But everyone on the streets has always told me that he was killed.

We know a lot more on the street than we tell the outside world or the police. And everyone knows the truth about things that go on. But we just keep quiet.

Certainly, these two young men do not keep quiet. But, neither do they provide here the kind of testimony that would break the cycle of violence and silence, the kind of information that would lead to arrests and convictions in any of the unprosecuted murders. For of course, they can't. If a witness protection program is neither incentive enough, nor safe enough, to encourage them to break the code of silence, the emphatically public nature of the site-specific installation is hardly the arena in which to name names and assign guilt.

But even if the names of the murderers, the perpetrators, cannot be spoken here, the names of the victims can be and are, repeatedly. Michael MacDonald identifies each of his brothers by name—Davey, Frank, and Kevin. What is striking about his descriptions of each brother's death, wrenching as each is in its tragic particularity, is that we learn, not their ages at the time of their deaths, but his. He was only thirteen when Davey died, sixteen at Frank's death, and seventeen at Kevin's. A witness to the first death, MacDonald's life—his youth and adolescence—is one that has been structured by the deaths of his siblings, by that staggeringly literal repetition, by the unremitting cycle of violence that has consumed both his family and his innocence. Each subsequent death repeats the event of the first, experientially and psychically, MacDonald's own family history becoming the very site of traumatic repetition and return. The cycle of violence itself produces the recurrent site for the psychic need to repeat, resulting in an inescapable, rather than inadvertent, experience of belated witness, each subsequent death in the family at once unique and yet repetitive, another traumatic loss through which to bear witness to the first.[24]

And in a neighborhood whose ties are fundamentally familial, whose loyalties and allegiances are predicated on a shared ethnicity, a shared past, each death is, in some sense, a death in the larger family, a death in the Boston-Irish community. For Terry Titcomb, born and raised in the Bunker Hill Housing Development, that notion of family is articulated as intensely personal, registered and understood through the nuclear family. Of her "three boys: Al, Kirk, and Chad," it is her son Al

who falls victim to Charlestown's violence, and she describes for the gathered audience the day of his murder, the day he was shot. But it is a death that at once is and is not of her family. Repeating the commemorative convention of the vigil, much like Sandy King, she offers up the date of Al's death. That date, November 22, is a date that need not be specified as the date of the Kennedy assassination. For if it is a date that holds a particular place in the history of this nation, it is a date that for the Irish-Catholic communities of Boston, looms even larger. For John Fitzgerald Kennedy, Jack, was and remains a blessed and beloved son, a source of pride and inspiration, his violent and premature death a terrible, tragic loss.

Thus even if here, in Titcomb's testimonial, that national trauma is eclipsed by the more immediate family trauma, her son's death expands and contracts to become the loss of yet another Irish-Catholic son. Through this coincidence, this uncanny repetition of dates, the individual loss of a mother is at the same time the larger loss of Boston's Irish Catholic community, if not also the nation more broadly, and vice versa. But perhaps uncanny is the wrong word in this instance of traumatic repetition. Repetition is not uncanny when these crimes, murders, and deaths simply keep taking place. That one brother can lose three siblings in a space of four years suggests that such communities have become nothing short of war zones, in which the death of a young man is not exceptional, but sadly, quite routine, and often, it would seem, inevitable.

For Enos, that element of repetition is one that makes her own loss insistently and unrelentingly present. Using language that makes vividly clear the belated temporality of trauma, she says,

> We're a community of people who really care about each other, and it's just so hard to imagine that this hurt could happen here. My life is very different now. It was always centered around my family. Now I never have that feeling of contentment when I go to bed at night, that my whole family is together. And sometimes, in the middle of the night if I hear an ambulance, *I just relive that night all over again.* It feels like something's wrong, somebody's really hurting somewhere, and I always say a little prayer because I hope they will be safe, whoever that ambulance is answering for. (emphasis mine)

But safety will not come until the "code of silence" is lifted, until the language of witness hovers not as spectral trace in the night sky of Charlestown, but as admissible testimony in the courtrooms of Boston.

* * *

As Giorgio Agamben contends, in an account of the witness that is deeply indebted to and structured by the writings of Primo Levi, particularly Levi's indictment of the morally ambiguous position of the survivor,[25] in the aftermath of Auschwitz there has been a confusion of juridical, theological, and ethical categories.[26] What interests Agamben in this confusion, this fusion, is the way in which ethical categories are forever "contaminated" by the law, by questions of guilt, responsibility, innocence, and pardon. Ultimately, on Agamben's account, neither truth nor justice is at stake for the law, but judgment. In the face of the crimes of Auschwitz, it has become clear that the law, even if it could and did convict and condemn certain perpetrators for their crimes, rendered judgment that was incommensurate with the enormity of those crimes.

But the question of incommensurability is not the only failure in the juridical process. So too, is the very category, the very concept of witness. Here, Agamben's gambit is in part, etymological. As he points out, before turning specifically to Levi's writings, there are two words in Latin for witness. The first, *testis,* from which testimony derives, signifies the person who, in a court of law, is in the position of the third party.[27] The second, *superstes,* signifies a person who has literally stood over the prostrate body of a defeated enemy, who has lived through the event, who has experienced it from beginning to end and, as such, can bear witness to it. This second kind of witness is, as Agamben makes clear, a survivor. But even the survivor is not, as Levi already pointed out, a "true witness," a "complete witness," for his or her testimony is compromised by the very fact of survival. As Levi writes:

> I must repeat: we, the survivors, are not the true witnesses. . . . We survivors are not only an exiguous but also an anomalous minority: we survivors are those who by their prevarications or abilities or good luck did not touch bottom. Those who did so, those who saw the Gorgon, have not returned to tell about it or have returned mute. . . . We who were favored by fate tried, with more or less wisdom, to recount not only our fate but also that of the others, indeed of the drowned; but this was a discourse "on behalf of third parties," the story of things seen at close hand, not experienced personally. The destruction brought to an end, the job completed, was not told by anyone, just as no one ever returned to describe his own death. Even if they had paper and pen, the drowned would not have testified because their death had begun before that of their body. Weeks and months before being snuffed out, they had already lost the ability to observe, to remember, to compare and express themselves. We speak in their stead, by proxy.[28]

What remains, then, for Levi and Agamben, is less a "true" witness than a *prosthetic* witness.

And it is by way of that notion of proxy, as it may be culled from the writings of Levi and Agamben, that I want to return now to the artistic project at hand, to Wodiczko's video work of prosthetic witness, and pursue the particular form of witness it authorizes and advances. Those who come to speak from the top of the Bunker Hill Monument, who literally stand above, the projected images of their faces looming over the streets of Charlestown, are a very particular kind of witness, offering a very particular kind of testimony. They have already foregone the juridical possibilities of testimony, refusing to share their knowledge, to bear witness as a "third party" in a court of law. But in some sense, even as familial survivors, even by way of their *relation* to the murdered and the murders, they are not "complete" witnesses. Even the brother who witnessed his siblings' deaths cannot speak that experience, he can only speak his own, a fact that is brought out most fully in his speaking of *his* age, not theirs. Instead, they speak from the domain of their memory, partial and prosthetic as it is, sharing idiosyncratic details, clasping photographs, their words and images offered up to the microphone and the lens of the video camera, which is itself, like its subjects, yet another partial and prosthetic witness.

As the preceding discussion I trust makes clear, Wodiczko's *Bunker Hill Monument Project* did not (and could not) transform the monument into a belated witness, even if that historical monument did, like its surrounding citizens, bear silent witness, if only by virtue of its persistent presence, to many an unprosecuted crime. But Wodiczko's project did provide the citizens of Charlestown with a situation in which to share their thoughts and memories, to make the victims, even if not the perpetrators, known, within and beyond the community. And, perhaps most important, on those three nights that the monument glowed with the light of the projected participants' faces, their voices disrupted the silence that had blanketed the neighborhood. The project arrested, even if only temporarily, the endless cycle of violence.

Unable to bear witness, it could be said that the ethical gesture of the subjects, and, in turn, of the project, was not testimony, but interruption.[29] For what the project offered Charlestown, in addition to the sheer spectacle of a public art installation whose evanescent beauty was commensurate with its fleeting invocation of extinguished young lives, was an intervention into that urban space, an end to silence, and an end, even if only briefly, to violence. And in that interruption, if not enduring arrest, I would suggest that the *Bunker Hill Monument Project* remains fundamentally related to those projects Wodiczko seemingly aban-

doned when he left behind questions of homelessness and alienation and turned to the subject of urban violence and traumatic loss. That is, as much as the *Bunker Hill Monument Project* is structurally and methodologically similar to his Krakow and Hiroshima projects—projects that deploy and depend upon analogous technologies of display and testimonial—it is also conceptually quite close to his work on the immigrant, work that is predicated on interrupting situations of fear and alienation and producing instead, situations of wonder and hospitality. For, like his *Xenology* project, a series of works, including *Alien Staff* (1992), *Mouthpiece* (1993), and *Aegis: Equipment for a City of Strangers* (1998), all involving equipment designed to protect the foreigner from violence or injustice (*aegis* the Greek name of the protective coat worn by Athena), the *Bunker Hill Monument Project* calls for an analogous safety and justice.

As Rosalind Deutsche writes of Wodiczko, drawing deeply and explicitly on the work of Emmanuel Levinas, and attending specifically to his project *Aegis:*

> The ethical interruption, like that of a thunderstorm or angel, fissures the space of the city just as it fissures the space of the self, violating what is already violent: forgetting of the other in the privatization of urban space. . . . In remembering to entertain strangers, Wodiczko's equipment for immigrants protests the forgetting of the other in contemporary images of the city. Following Levinas, we might say that it performs an ethical interruption of urban images, for ethics, he says, is "vision without image, bereft of the synoptic and totalizing, objectifying virtues of vision."[30]

If in *Aegis,* and in the *Xenology* project more broadly, it is the explicit goal of the technologically displaced images and voices to undo the structuring binary of identity formation, and, following Levinas, make the stranger, the alien, seem less strange,[31] that is certainly not the Bunker Hill project's goal, given its location in and attention to the problems of an insular community. Nevertheless, like angels hovering above the denizens of Charlestown, the looming faces of the project's participants do fissure the urban space of the neighborhood, a space that has already been deeply violated, deeply wounded by its losses. And in their call to remember, to acknowledge, to bear witness, even if they themselves fundamentally cannot, they suggest the possibility that such an urban body might be made, if not whole, at least someday better equipped to handle its fractured and fractious identity.

If a project might be said to hold within it something of a utopian possibility, the question is how that future might be achieved. And I

would address that question by posing a more direct question, namely, what if this project, like *Aegis,* had taken up, following Levinas's ethical imperative, the question of the stranger, the question, in the end, of the other who is both the self and the neighbor? In other words, what if its participants had spoken of difference rather than sameness, what if this project had embraced other aspects of the community? For it is precisely in the presumption of sameness, in the steadfast adherence to a notion of cultural commonality, codified through silence, that everyone else becomes a stranger, and with that, an adversary, a threat, an enemy. Be it the policeman walking the beat, the young urban professional moving in to the federal-style townhouse on Monument Avenue, the immigrant working in the corner deli, or the African-American family living in the apartment next door, everyone except the perpetrator becomes the other. And ultimately, it is only the murderer, his sameness enshrouded in a protective veil of silence, who does violence to the community, while it is the presumptive other who animates, rather than extinguishes, life in the neighborhood.

"Don't shoot until you see the whites of their eyes." Every Boston-area school child learns those words of revolutionary combat, said to have been uttered by Colonel William Prescott, whose statue stands at the base of the Bunker Hill Monument. In the hypothetical and utterly utopian Wodiczko project I am proposing, one that echoes the politics of *Aegis* and *Xenology,* that apocryphal cry of battle would be transformed into a call for peace, producing a community of strangers as neighbors. "Don't shoot. Until you see the whites of their eyes. For until then, you do not and cannot know your enemy. And once you come close enough to know your enemy, to make that stranger a neighbor, to understand that we are all strangers, even to ourselves, perhaps that need for violence will have passed."

Such might be the call of Georgio Agamben, who, in another work, proposed a different kind of political subject, a different kind of political subjectivity, putting forward the figure of the refugee as a figure of utopian possibility.[32] Such might be the call of the eternally silent monument, if it had heard, understood, assimilated, a different relation to the other. But even if such words were not uttered by Wodiczko's video subjects, such was, ultimately, the call of Emmanuel Levinas, whose ethic of nonviolence seems particularly relevant to Wodiczko's looming loop of projected faces. As Levinas writes, and I condense:

The approach to the face is the most basic mode of responsibility. . . . The face is not in front of me, but above me; it is the other before death, looking through and exposing death. . . . thus the face says to me, you

shall not kill. . . . To expose myself to the vulnerability of the face is to put my ontological right to existence into question. In ethics, the other's right to exist has primacy over my own, a primacy epitomized in the ethical edict: you shall not kill, you shall not jeopardize the life of the other.[33]

The project belongs, however, not to Levinas, or Agamben, but to Wodiczko, and, albeit briefly, to the bereaved and beleaguered residents of Charlestown, to whom it does offer, if nothing else, a moment of commemorative contemplation.

For this project is one that takes video at its literal word, that interrupts the space of urban violence and decay and says, "I see." Blind as a monument may be, it is seen by many, particularly when it is a 221-foot tall obelisk, perched at the top of a hill, its towering surface an ideal screen for public art. That Wodiczko sought to imagine the possibility that the monument might "see," that it might "speak" all that it had witnessed in its many years of silent watch, that it might "remember," was a fundamentally utopian gesture. That he afforded the citizens of Charlestown a chance to speak was a way of realizing, even if only asymptotically, prosthetically, partially, that utopian dream. It allowed the citizens of Charlestown to disrupt the culture, even if not break the code, of silence. It allowed the citizens of Charlestown to perform the act of testifying, even if not, given the juridical and ethical limits of that form, of fully bearing witness.

Through the use of video, mothers and sons spoke their stories, their memories, their experiences, giving voice to a lifetime of loss and disenfranchisement. And through the use of video projection, the monument, the eternally silent witness, mute bystander to a neighborhood's history of economic decline, social fracture, and self-destruction, was able to produce the effect of witness and declare what it could not depict, to envision what it could not effect. It was able to speak on those three nights in 1998, not "I see," for, of course, it couldn't, but instead, through the screening of testimony on its looming form, "I saw."

In short, Wodiczko's project brought together two forms, one, the monument, explicitly dedicated to the project of remembrance, the other, video, at least nominally dedicated to the activity of seeing, if not also to the experience of having seen. And in superimposing one form upon the other, video projection upon monument, the project at once insisted upon and blurred those differential functions, pointing to the capacity, and incapacity, of each form to fulfill its expected function. For it is not so much that the monument comes to "see" and the video

to "remember." Rather, through the displacements and deferrals of the technology of projection and the temporality of testimony, the monumental video projection, belatedly and by proxy, offers up, at the same time that it necessarily forecloses, the possibility of bearing witness. It invites us, as spectators, to bear witness to these witnesses, however delayed and delimited their testimony may be.

<p style="text-align:center">* * *</p>

As a counterpoint, if not also a conclusion, to the preceding discussion of Wodiczko's monumental work of video projection, his intervention into a culture of silence, a culture, more broadly, of historical amnesia, I want to return to the work of Tony Oursler, an artist, as I have already discussed at the outset of this chapter, similarly concerned with the technology of projection. Certainly, on the level of visual analogy, his "video effigies" offer a striking point of comparison to Wodiczko's projections. Oursler's tiny talking heads are screened not on the towering façades of public monuments, but instead, on the suspended, submerged, or sandwiched "faces" of limp, often entirely disembodied dolls and deflated mannequins (figure 7). Similarly, as opposed to the public spaces occupied, if only temporarily, by Wodiczko's monumental video projections, Oursler's diminutive video effigies are generally trapped within the nonsite-specific location of multiple gallery and museum installations and exhibitions. [34]

Like Wodiczko's witnesses, Oursler's subjects speak directly to the camera, their sessions then screened before a public. But Oursler's subjects are actors, and their narratives are precisely nonnarrative, the rantings and ravings of a world of dissociative disorders. In such sculptural installation pieces from the 1990s as *Hysterical* (1992), *Judy* (1994), *Let's Switch* (1996), *MMPI (Red)* (1996), and *Side Effects* (1998), [35] Oursler's projected subjects perform parts that enact not the belated temporality of witness, but instead, the perpetual present of the schizophrenic. Victims, too, they recite, over and over again, phrases that have less to do with traumatic experiences that cannot yet, if ever, be put into words than with the ongoing immediacy of their terror, their abjection, their dysfunction, speech emptied of the possibilities offered by either testimony or therapy.

Hysterical as opposed to historical, Oursler's works literalize in the form of video installation Roland Barthes's insight into the very epistemological and ontological crisis that drives and defines the practice of history, the status of history, and the possibility of witness in the

FIGURE 7
Tony Oursler, *Hysterical*, 1992. Courtesy of the artist and Metro Pictures Gallery.

present. As Barthes writes, reflecting on the irrevocable distance that separates him from his deceased mother, from a photograph of his mother as little girl, from his mother in a time before he was born:

> History is hysterical: it is constituted only if we consider it, only if we look at it—and in order to look at it, we must be excluded from it. As a living soul, I am the very contrary of History, I am what belies it, destroys it for the sake of my own history (impossible for me to believe in "witnesses"; impossible, at least, to be one . . .").[36]

In their hysteria, Oursler's tiny screaming video projections may nevertheless achieve the kind of monumentality foreclosed in more traditionally historical or monumental works. For if the function of the monument is not just, or not only, to remember, but literally to admonish, to warn, Oursler's effigies would seem to do just that, making palpable, visible, and horrifying the considerable costs of living not just in the absence of historical knowledge, but, even more, the considerable consequences of living in the absence of memory. Furthermore, as much as Oursler's effigies enact the amnesiac present of their suffering subjects, they may also offer a critique of the medium itself and its capacity to bear witness. With the perpetual present of the video loop structurally repeating the very psychic condition of the dissociative subject, Oursler's video installations make clear that even if video bears witness, records and screens that which has come before the lens, it has no greater hold on history and memory than any other medium. For repetition is not, in the end, the same as remembrance. And so the video loop comes to stage belatedness as yet another permutation of perpetual presence, in which the testimony of the witness gives way to mere words.

The responsibility to remember lies not in video, but in the viewer, in the citizen, as Wodiczko's public projects make clear. In their temporally bounded periods of installation, Wodiczko's works arrest the perpetual present of the video loop, if not also, disrupt what might be termed the perpetual presence of the monument. In the case of the *Bunker Hill Monument Project,* the video project(ion) was there for three nights only to disappear, its absence henceforth invisibly expanding the meaning of the monument and extending the responsibility of memory to those who witnessed, not the crimes, but their belated representation as video testimony. In the end, audience comes to share with video the ethical imperative that comes with witnessing, the ethical imperative that comes with seeing and having seen.

3 NEGATIVE IMAGES

How a History of Shadows Might
Illuminate the Shadows of History

*. . . all agree that it began with tracing
an outline around a man's shadow.*

PLINY THE ELDER

In the early 1990s, Glenn Ligon produced a series of paintings, among
them *Untitled (I Feel Most Colored When I Am Thrown Against a Sharp White
Background)*, *Untitled (How It Feels to Be Colored Me)*, *Untitled (I Am an In-
visible Man)*, and *Untitled (I'm Turning into a Specter Before Your Very Eyes
and I'm Going to Haunt You)* (figure 8). Vertical canvases of roughly hu-
man scale, their white surfaces are densely covered, not with figures,
but with stenciled black letters, fragments of literary texts.[1] The text
fragments, taken from the writings of James Baldwin, Zora Neale
Hurston, Ralph Ellison, and Jean Genet run across the canvases with the
strict horizontality of the modernist grid, if not also the ruled paper of
the elementary school classroom, and repeat down the surface of the
paintings with an increasingly thick and free impasto. Composed of oil-
stick and gesso, the letters and words devolve from clarity to obscurity.
On each canvas, figure progressively bleeds into ground, and the ini-
tially legible pictorial surface gives way to pure abstraction. While
Ligon's text paintings enact with a certain gravitational and entropic in-
evitability their downward movement from meaning to materiality,
from word to image, his formal insistence upon the opacity of the words
and the painterly medium with which they are rendered does not fully
undo their claims to semantic transparency, that is, their claims to ref-
erence and meaning. For even as the stenciled words come to be con-
sumed by the sheer materiality of paint, even as the textual fragments
come to be interred by and upon the very surface of the canvas, their
subject, their social referent, is not. In each of Ligon's paintings, the ex-
perience of the black subject in a white world remains, for all its mate-
rial occlusion and eventual erasure, stubbornly, vividly present.

FIGURE 8

Glenn Ligon, *Untitled (I'm Turning into a Specter Before Your Very Eyes and I'm Going to Haunt You)*, 1992. Oil stick and gesso on panel. Philadelphia Museum of Art. Courtesy of the artist.

Much has and might well still be said of Ligon's painterly negotiation of African-American identity, and, even more to the point, African-American masculinity, both in regard to this series of paintings and to his work more broadly.[2] In the case of this particular series of Ligon canvases, the painterly rendering of stenciled black type against a white background functions as a means of starkly representing, even if not actually picturing, the issue of racial difference, black set against white. The black letters formally instantiate their obvious difference from the framing context, the white painterly field into and upon which they are stenciled. At the same time, the letters form words that express a set of literary responses to the inherited historical burden and ongoing limitation of such categories of identity. On Ligon's canvases, black words (both literally and figuratively) serve as the vessel for a language of color. They serve as a vehicle for a literary and painterly encounter with questions of blackness, and as a register of social and cultural experience.

Like Jasper Johns's early paintings, to which Ligon's are at once deeply and manifestly indebted, Ligon's paintings literally represent language. They give us painted words, iterations that are at the same time, images. Like Johns, they render as aesthetic, if not also, philosophical object, the systems of representation through which meaning is at once designated and deferred.[3] Unlike Johns's painterly use of language, however, Ligon's text paintings insist not just upon the felicities and failures of linguistic and pictorial signification, but upon those of social signification. And as such, the concern for language evinced in Ligon's work is less linguistic or semiotic than political, for, as Ligon's paintings make painfully clear, it is through words and language, if not also through images, that the subject is interpellated, and, moreover, that prejudice and discrimination endure.[4]

Composed of mined and mimed words, Ligon's canvases are at once emphatically declarative and at the same time, silent, renunciatory. Their refusal to depict what they describe offers in the place of an image a form of painterly iconoclasm. Their (black) subjects are conjured in and by words alone—"I am an invisible man," "I'm turning into a specter before your very eyes." To pursue the very words that Ligon represents, their subjects hover somewhere in and between the categories of the "invisible" and the "spectral," their subjectivity neither fully speakable nor seeable.[5] That is, as Ligon's paintings both enunciate and enact, as much as blackness is that marker of difference that makes certain subjects visually recognizable and socially legible, it is also blackness that renders certain subjects ultimately invisible, spec-

tral—a presence that haunts American social history and the white cultural imaginary.

As much as these stenciled words describe the experience of racialized identity in America, of self constituted against other, conjuring the violence and violations of the penal system, wanted posters, stationhouse booking photographs, and police line-ups, they also suggest the black body, dematerialized and yet also doubled, as specter, as shadow. And it is that specter, that shadow that I want to pursue here. As Ligon paints black words against white, his paintings intimate and instantiate not so much the condition or category of painting, but another visual strategy, another representational technique, namely, the silhouette, that antiquated practice in which the form of the body, the shadow of the body, the body "thrown against a sharp white background," literalizes and concretizes social conditions of blackness.

What I want to suggest here are the ways in which that spectral presence, and even more, that spectral structure, undergirds Ligon's work. Indeed, a spectral structure is absolutely central to his representational strategy, formal and thematic, as is articulated, even accentuated, by the apt and allusive appropriated textual fragments that ground his pictures. It is their invocation of invisibility, their speaking of spooks and specters that gives additional resonance and reach to Ellison and Genet's painted words.[6] But so too is it the function of Baldwin's words, which manage, in their social message, also to anticipate and echo the very practice that will come to characterize Ligon's work. Where Baldwin writes, "I feel most colored when I am thrown against a sharp white background," Ligon paints black against white, and in so doing, materializes and monumentalizes both typographic convention and social condition, offering spectrality as visual spectacle.

A conceptual structure for these visually renunciatory, foundational paintings, the silhouette emerges as a forthright formal element in the ensuing body of Ligon's work. For example, in his print series *Runaways* (1993), Ligon, in a complicated and displaced act of self-portraiture, appropriates the visual format of the nineteenth-century fugitive slave poster (figure 9). The prints feature textual profiles of Ligon, descriptions culled and solicited from friends and acquaintances, who were asked to pretend they were reporting his disappearance to the police. Among them are such description as, "Ran away, Glenn Ligon. He's a shortish, broad-shouldered black man, pretty dark-skinned, with glasses. . . . Nice teeth." Each profile is printed in a box, set below Ligon's appropriations of nineteenth century depictions of slave masters and runaways, in black and white, and frequently, in profile. The

Ran away, Glenn
Ligon. He's a shortish broad-shouldered
black man, pretty dark-skinned, with
glasses. Kind of stocky, tends to look down
and turn in when he walks. Real short
hair, almost none. Clothes non-descript,
something button-down and plaid, maybe,
and shorts and sandals. Wide lower face
and narrow upper face. Nice teeth.

FIGURE 9 Glenn Ligon, *Runaways*, 1993. Courtesy of the artist.

verbal accounts offer a series of profiles that do and do not capture the contemporary subject who is the young, black male artist.

In his painterly project *Profile Series* (1990–91), the very words, the "profiles" ("A loner, shy and sad . . .") that purport to describe the defendants in the Central Park Jogger Case, are partially darkened or lightened to produce looming shadowy profiles, yet another incommensurable portrait of young black men (figure 10). Tapping into public memory of the "wilding" black boys who allegedly raped and brutalized a white female jogger, the textual descriptions offer individualized portraits of the adolescent subjects, even as the images retain all the generality of the form of the profile portrait. In both series of works, the silhouette emerges as a significant and recurrent visual device for Ligon, a means of figuring something about historical and even quite recent conventions of depicting, or perhaps more appropriate, *capturing* black male subjects.[7]

What I will suggest in the course of this chapter is the following: the return of the antiquated practice of the silhouette, of the shadow as concretized form, is part of a larger logic at work in contemporary practice. It is a logic that allows for a particular kind of engagement with the subject of history, or, even more pointedly, the subject of historical trauma. It is a logic in which the subject of representation is at once absent yet present, schematized yet utterly recognizable, neither fully visualized nor materialized, but nonetheless, legible. It is a logic in which the subject is *conjured* more than figured. "I'm turning into a specter before your very eyes and I'm going to haunt you," paints Ligon, by way of Genet. Those words come to speak, not just from the authorial positions of writer and painter, but from the very condition of painting, of visual representation itself, and articulate something of the logic that is at stake in such contemporary practice, a logic that is, in some sense, in all of its pervasiveness and particularity, an ethics of representation, a mode of encountering traumatic history. Silhouette, shadow, specter: each form, as form, establishes an ethical relation to traumatic history, and, moreover, to its subjects, its victims. Such forms acknowledge, in their refusal of material figuration and in their insistence upon constitutive absence, at once the incommensurability of representation and, in turn, the ways in which these unrepresentable subjects, historical and human, come to haunt the present while demanding at the same time that they fundamentally defy representation, and with that, recognition. In short, such forms establish an ethics of representation that is predicated on a logic of spectrality,[8] on marking precisely that which cannot be represented, yet making it somehow, legible.

He is one of the four defendants
who live at the Schomberg Plaza
a tan high rise overlooking a
drained pool at the northern
end of Central Park. The fif-
teen year old, who is charged
with raping and beating the
victim with a pipe, was des-
cribed as a particularly shy boy
Neighbors said his father, who
they said was a madman, en-
forced curfews for Steve and
his two younger brothers.
Neighbors said the boys' mot-
her worried about negative
influences. "He was always
at home his mother raised him
at home," said a woman in the
building. A member of the Ten-
ants Council, Marilyn Davis, at
the building, added. He's so
shy he didn't even look at girls.
A young girl who gave her name
as Michelle and who lives in the
Schomberg Plaza said she had
always thought of the youth
as strange, who would shoot
baskets by himself. There was
something sad about him, she
said. "I think he wanted to be liked

FIGURE 10 Glenn Ligon, *Profile Series*, 1990–91. Oilstick and gesso on panel. Courtesy of the artist.

If the silhouette is a facet of Ligon's ranging practice, it is the defining method of Kara Walker's oeuvre. As I will demonstrate, it is Walker's use of the silhouette, that is, of the technique of cut-paper profile, and her return to its historical form, if not its historical function, that fully mobilizes such a logic and ethics of spectrality and exploits the possibilities of a form that is, to cite Walker's own description of the silhouette, "both there and not there."[9]

<p style="text-align:center">* * *</p>

The silhouette takes its name from Louis XV's finance minister, Etienne de Silhouette, whose miserly policies came to be equated with the economical language of the cut-paper profile, a hobby he was known to indulge.[10] The specific use of scissors and paper not withstanding, the silhouette stands not merely at the threshold of modernity, but at the very threshold of visual representation itself. It is a representational practice, a representational form, which dates back to the mythic moment when the Corinthian maiden traced the shadow of her imminently departing lover on the wall, outline left to stand as a melancholic memorial object. With examples ranging from the petroglyphs of prehistoric cave dwellers in the Paleolithic era to the projections and installations of multimedia artists in the present, the contemporary French artist Christian Boltanski perhaps most prominent among them,[11] it is neither aggrandizing nor hyperbolic to claim that the shadow — stilled and arrested as silhouette — has fundamentally structured a history of visual representation.[12]

Even before the silhouette became a commonly practiced and commercialized art form, a preferred mode of portraiture both prior to and during the first decades of the advent of photography, it was an important tool in physiognomic studies, foremost among them, those of the Swiss theologian Johann Caspar Lavater. For Lavater, whose larger project was to classify and characterize people on the basis of nationality and race, the profile was seen as particularly revelatory, establishing a causal relationship between physical appearance and moral character.[13] A conflation of empirical method and personal prejudice, the silhouette was a visual form that allowed just enough of the subject to coalesce for Lavater to isolate and deindividuate facial characteristics so their proportions could be quantified in the name of racial theory. Given such a tainted history, it is of further significance that in the late nineteenth century, the silhouette came to be practiced by a number of African-American "cutters." A tool once used in the service of oppres-

sion was now firmly in the hands of the oppressed, as is exemplified by Moses Williams, who made cut-paper portraits at Charles Wilson Peale's museum in Philadelphia.[14] That is, despite its tainted history in the pseudoscience of physiognomy, the silhouette came to be a form of visual representation available to, if not also constitutive of, the newly-freed black subject.

Take, for example, the case of Sojourner Truth. Born into slavery in 1797, Isabella van Wagener changed her name when freed and is perhaps best known for her now canonical feminist speech "Ain't I a Woman" of 1851. Sojourner Truth was one of the first African-American women to have her image widely disseminated, its sale a means of supporting her preaching. Printed on a *carte de visite* was not only her image, in silhouette, but the words "I sell the shadow to support the substance." Manifestly understood as a "shadow," as a spectral trace of subjectivity rather than an instantiation of "substance," the silhouette popularized in its very formal qualities the complex relationship of representation to its human subjects. Certainly, there are other aspects of the silhouette and its history that might well be discussed here. But it is these particular aspects of the silhouette, namely, its role in the history of pseudoscientific studies of race and difference and, moreover, its place in a history of African-American self-representation, that are directly relevant to its reappropriation as a visual sign in the work of contemporary African-American artists.

What is the relation of the silhouette to its subject? Two other terms that were used historically to describe the silhouette, namely, *profile shade*[15] and *schwarze Kunst* (black art)[16] are relevant here. The first term, *profile shade,* makes manifest a simple yet essential fact. For the silhouette to achieve legibility and approach likeness, it had to take on the symbolic form of the profile.[17] In other words, it had to represent from the side. A shadow cast from the front or the back produces the human subject, and, more to the point, the human head, in nothing but the most generic of forms, variations on an ovoid. It is only from the side that distinguishing features are captured in cast shadow and that recognition is, or can be, achieved.

But as the Lebanese video artist Walid Ra'ad's work makes patently clear, even the silhouette does not guarantee likeness, and in turn, the possibility of identification. As we know from such forms as the documentary film or the news interview, subjects who fear the consequences of speaking, appearing, or testifying are often "blacked out" to preserve their anonymity, their darkened form meant to cloak rather than reveal their identities. In one particular scene from Ra'ad's 1999

video piece *The Dead Weight of a Quarrel Hangs,* an investigation of the possibilities and limits of producing a history of the Lebanese civil wars (1975–91), the silhouette functions as an act of social resistance.[18] Composed of found footage from government cameras, if not, given Ra'ad's blurring of fact and fiction, its belated simulation, we see the ways in which surveillance operations can be rendered impotent in the face of such everyday occurrences as the blinding light of a setting sun. As demonstrated by the video footage Ra'ad includes in his piece, each day at sunset the activity on Beirut's Mediterranean boardwalk, the Corniche, escalates, a certain freedom afforded by the very fact that all of the strollers and gatherers are rendered unrecognizable in such light, their distinguishing physical features and facial attributes giving way to the darkened sameness of the silhouette.[19]

If Ra'ad's piece reveals something of the contemporary history of Lebanon, it also reveals something about the silhouette. While the silhouette as representational form is predicated historically on the possibility of recognition, it can always, or in some sense, must always contend with its other, anonymity. For the silhouette, based as it is in the projection of a shadow, is less a likeness, even if the profile secures something of the identity of the represented subject, than a semblance, forgoing much of the category of mimesis. That is, the silhouette hinges, as Victor Stoichita has so persuasively argued, not on resemblance, but semblance.[20] And semblance, if we look to its etymology, is a very particular representational category. For a semblance is, at its etymological origins, a phantasm, in other words, a specter. Conjured and then concretized, the practice of silhouette, like that of black magic, is indeed a "schwarze Kunst," a "black art."

That the practice of this "black art" should return in the work of several contemporary African-American artists signifies more than might be allowed by this facile play on words. Whether we look to the work of Glenn Ligon and Kara Walker, or to that of the South African artist William Kentridge, the appropriation of the antiquated form of the silhouette tends to share a certain subject. In each artist's work, the silhouette is used as a means of figuring the spectral bodies of traumatic national histories. That the silhouette emerges as the oblique means of representing and encountering traumatic history is at issue in the pages that follow, as I turn specifically to the work of Kara Walker. Conjuring up with the form of the silhouette the spectral bodies of African American subjects, Kara Walker's work may be seen as a form of pictorial séance. For in her work, Walker brings back the bodies, the historical subjects, of the antebellum South, and renders concrete

the ways in which those bodies, and that history, continue to haunt a nation.

* * *

In 1997, Betye Saar launched a campaign against any future display of "the negative images produced by the young African American artist, Kara Walker."[21] Enraged by what she took to be the reiteration and perpetuation of dated and demeaning stereotypes of black identity, Saar saw Walker's work, and the institutional support for it, as a betrayal of all that she and her generation of post–civil rights, activist artists had struggled to achieve. Twenty-five years earlier, it had been Saar's work that attempted to transform racial stereotypes into something positive and powerful. As Saar claimed of her own work, "The 'mammy' knew and stayed in her place. In 1972, I attempted to change that 'place' by creating the series *The Liberation of Aunt Jemima.* My intent was to transform a negative demanding figure into a positive, empowered woman who stands confrontationally with one hand holding a broom and the other armed with [sic.] battle. A warrior ready to combat servitude and racism."[22] To Saar, then, Walker's work had diverged deliberately and dangerously from the path prescribed for African-American artists. Unlike a previous generation's uplifting and regenerative practice, Walker's work was not an exercise in unleashing black power through an appropriation of iconic racist images culled from American vernacular culture. Instead, its repetition of negative stereotypes was seen only to reinscribe social and psychic structures of degradation and servitude, a pandering form of minstrelsy, a full-scale version of the "neo-black face art" practiced by the painters Michael Ray Charles or, more recently, Beverly McIver. In other words, rather than foment a revolutionary politics of liberation, Walker's work was seen to participate in furthering an insidious process of internalized enslavement.[23]

But if Saar's concern was manifestly about the "surfacing of the subconscious plantation mentality" and the "reinvention of the negative black stereotypical images,"[24] her critique nevertheless points not just to the ideological complexities and political implications of Walker's work, but to its very methods. For, what are Walker's silhouettes but "negative images." That is, not only do they traffic in the cultural reality and imaginary of demeaning (i.e., negative) stereotypes. But they are, in quite literal formal terms, negative images. Walker's works repeat the conventions of prephotographic contact images, negative images before the advent of the photographic negative. They give us shad-

ows, captured in outline, the tracings of bodies. Walker's works are, quite simply, and obviously, silhouettes.

Silhouettes of stereotypes, in other words, negative images of negative images. Were pictorial representation a mathematical equation or a linguistic construction, Walker's double negatives would cancel themselves out, become, instead, positives, in other words, affirmations. But that is not their logic or signifying structure. At stake and at play in Walker's work is negative form coupled with negative content, one reinforcing rather than negating the other, doubling rather than defusing their power, a negativity at once unredeemed and unredeemable. The dialectical structure of these forms demonstrates the ambivalence of the stereotype, which is, as Homi Bhabha writes, "as anxious as it is assertive," an ideological construction of otherness structured by the play of both "desire and derision."[25]

History as obscene fantasy, fantasy as obscene history, Walker's "negative images" instantiate a return of the repressed: history and its ugly iterations in both the culture industry and the cultural imaginary.[26] For Walker's cut-outs revive not only the antiquated form of the silhouette and the ambivalent power of the stereotype, but a set of popular genres as well. Take, for example, a massive, semipanoramic installation like *Gone, An Historical Romance of a Civil War as it Occurred Between the Dusky Thighs of One Young Negress and Her Heart* (figure 11). First shown in the fall of 1994 at the Drawing Center in New York,[27] Walker's *Gone* stages something of a spectacular revival and reenvisioning of *Gone with the Wind,* both Margaret Mitchell's 1936 novel and its 1939 cinematic adaptation starring Clark Gable and Vivian Leigh. But where in the film the political and historical context of the Civil War is relegated to a backdrop for the personal dramas and emotional upheavals of Scarlett O'Hara, in Walker's work the backdrop takes center stage. In *Gone,* fictional and filmic point of reference and departure come together with the epic and monumental pictorial genre of history painting to emerge, also with indebtedness to the protocinematic technology of the panorama and the cyclorama, as a phantasmagoric tableau of the crimes and characters of the antebellum South. A polymorphously perverse performance of the American past, rife with mammies and pickaninnies, belles and dandies (if not here, as in other of her epic works, sambos and carpetbaggers, too), Walker's stereotyped shadow-figures stage in *Gone* their own relation to a set of caricatures and stereotypes, and, at the same time, enact the history of slavery in and as modes of variously antiquated visual spectacles.[28]

If read from left to right (*Gone*'s expansive dimensions are 13 × 50

FIGURE 11
Kara Walker, *Gone, An Historical Romance of a Civil War as it Occurred Between the Dusky Thighs of One Young Negress and Her Heart*, 1994. Cut paper on wall. Courtesy of Sikkema Jenkins & Co., NYC.

FIGURE 12
Kara Walker, *Gone* (detail), 1994. Cut paper on wall. Courtesy of Sikkema Jenkins & Co., NYC.

feet), the scene begins, if it may indeed be said to begin, under a moonlit sky, beneath a framing tree, whose limbs are draped with the hanging moss that typifies the southern landscape (figure 12). For, of course, to "read" *Gone* in this way presumes that Walker's work follows some form of conventionalized narrative organization, which it may well not, given Walker's compositional predilection for the fragment. In any case, there, beneath the southern tree, a southern belle leans in toward

a gentleman, on tip-toe, for a kiss. Though the hands and chests of the amorous pair touch, their lips do not. For this is not, in the end, the "romance" at stake. Not only does a second pair of legs protrude from beneath the belle's ample hoop skirt, suggesting that between the white thighs lies, if not romance, certainly a more intimate act than the visibly unfulfilled kiss. The gentleman's sword, loosely affixed at his belt, does not point forward toward the belle to complete symbolically their union. Instead, it swings back to open the already disrupted dyad onto another, the sword's tip just grazing the bottom of a nude black child who has wrung the neck of a now limp and lifeless swan.

In front of the child sits a black woman, her long legs extended before her, her arm raised, her finger pointed, in a gesture of seeming approbation. Whether this gesture is directed at the violence of the child, whose open mouth suggests a response to a reprimand, or to the shenanigans of the couple(s) just behind her, is unclear. Just to the rear of the woman's back stands a disembodied head, at once a simple portrait bust but also, given the lurking violence of the tableau in which it appears, perhaps the remains of a gruesome beheading. A close match of the facial profile of the southern belle, though here, her lips are not puckered, but firmly closed, the unanchored silhouette nevertheless reads ambiguously. For at the same time that it is a female profile, whether the belle on the far left or not, what seems to be her hair also coalesces into the profile of another face, this one seemingly bearded and masculine.[29] As such, the bust is neither one nor the other, or, alternately, it is at once one and the other, an amalgam of the first two figures, the classic aesthetic and perceptual conundrum of Ernst Gombrich's duck/rabbit actualized in the combination of representational acuity and ambiguity that structures the silhouette.[30]

The ambiguity, the oscillation, of the bust suggests, then, the potential illegibility of race. For example, even as we might feel secure initially in recognizing race, in knowing full well that the "romance" begins not "between the dusky thighs of one young negress and her heart," but instead, between a southern belle and her gentleman, we can't be entirely sure. For "identity," some "essential" self that may be linked to a collective identity, is, in fact, potentially illegible.[31] That is, even as sartorial codes, hairstyles, exaggerated lips and buttocks and so forth, allow us to read and *recognize* these figures as racialized types, either black or white, we may indeed *mis*recognize them. And there lies the particular and peculiar power of the silhouette as form. Not only does the silhouette reduce the subject of representation to schematic form, to a "profile," to a semblance that derives its relation to the human subject more from its indexicality than its iconicity. But it reduces all of its

subjects, renders all of its figures, black. If the photographic negative performs the interesting trick of turning black into white and white into black,[32] the silhouette levels all such difference. White moon, white woman, black child, black woman, all are black in the traditional practice of silhouette. This leveling of difference, this production of blackness, makes manifest the possibility that the southern belle, in silhouette, could well read, were we not so acculturated in the recognition of the markers of race, as "dusky" negress. A perverse visual enactment of the "one drop rule," the black cut-out of silhouette in turn implicates the viewer in the social semiotics of reading and (re)producing racial difference.

There is a second pairing of figures that points as well, if not to issues of recognition and misrecognition, to the hybridity that both founds and confounds identity. The pairing, a young girl and boy perched on a hillock, depicts another "romance" that is also not, in the end, a romance. A young white boy stands with his pants down, shirt flapping, while a young black girl, on her knees, fellates him. If he is, as would be likely in such a pairing, the master's son, then there is indeed no romance here. Instead, this little scene prefigures that which closes out the tableau. There, a gentleman (the gentleman from the first visual vignette? the young boy grown?) hoists a black slave woman, still grasping her broom, upon his shoulders, his head hidden beneath her skirts, and carries her off to another grassy knoll and framing tree (figure 13). If these, finally, are the dusky thighs alluded to in Walker's lengthy title to the piece, this is, yet again, not a sentimental scene of romance. Instead, it is a scene of abduction, an abuse of power, a playing out of the structuring dynamic of the antebellum South, master over slave. Emptied of the classical weight of *Leda and the Swan* (for the swan has already been strangled in an earlier visual vignette; there is no safety of allegorical displacement here),[33] Walker's final image is instead rooted in a different set of mythologies and violent histories.[34] Jupiter needs no cloaking on the plantation, or, indeed, subsequently, in an American culture that has made the sexual violence of a white man assaulting a black woman visual spectacle. Think of such cultural landmarks as *Roots,* where such violence appears in the guise of the historical drama or such films as *Mandingo,* where the violence is variously authorized by the forms of pulp fiction or the pornographic.[35]

But before that final scenario of abduction and impending sexual violence, we see two other single figures: one aloft, as if thrown into the air by the fellated boy, whose arm might be seen to have tossed this figure away, and one below, at the foot of the hillock. But just as the one

FIGURE 13 Kara Walker, *Gone* (detail), 1994. Courtesy of Sikkema Jenkins & Co., NYC.

figure (rather androgynous) floats above the scene, unmoored, the clothing (a skirt?) at once a parachute and an obscene, distended organ, the other figure, clearly a woman, lifts one leg to bear, in rapid succession, two children, babies dropping from between her thighs like the shit that pours forth from various figures, male and female, in other of Walker's more explicitly scatological scenes. That a finger on one of the birthing mother's hands points back toward the coupling, albeit not procreative, on the hillock above her, suggests the possible parentage of her progeny, a mixed parentage, the miscegenation that is figured as well in the final pairing, white man and black woman, the abduction a prelude to the act that, for all of the horror of the scene, is not, though it is elsewhere in Walker's oeuvre, depicted.

Gone, An Historical Romance of a Civil War as It Occurred Between the Dusky Thighs of One Young Negress and Her Heart. Gone, emptied, evacuated from this scene is not only a "historical romance" that was *Gone with the Wind* or any number of its literary or filmic antecedents or inheritors. Gone is any pretension to recuperating that history as romance, to transforming it into the visual pleasures of popular culture, even as it plays on and with its antiquated forms. For all of the vaudevillian antics and protosurreal visual spectacle of the scene, in place of a historical romance, there is only the scene, if not the seen, of historical trauma. Less an act of belated witness—for what would that mean here?—Walker's work revels in an imagination fueled by the textual residue of everything from slave narratives to recent popular culture.

Thus, unlike the 2001 novel by Alice Randall, *The Wind Done Gone,* which similarly, and even more explicitly, took *Gone with the Wind* as its point of departure, *Gone* is not an attempt to assert or reclaim the historical voices of the oppressed, in the case of Randall's work, Scarlett O'Hara's mulatto half-sister. Rather, it is an attempt to give form to the repressed, to all that haunts the American imagination. Foregrounding its own relation to the subject depicted, Walker's work is neither the obvious act of appropriation that may be found in Randall's work of historical fiction, nor, for that matter, the virtuoso act of ventriloquism that animates Toni Morrison's extraordinary 1987 novel *Beloved.* In Morrison's novel, the traces of history (the tale of runaway slave Margaret Garner, who, fearing capture, rather than see her children returned to bondage, attempts to murder them) come together with an authorial imagination and voice to produce the story of an escaped slave, Sethe, haunted by the ghost of her dead child, Beloved. Walker's work offers no such story.

The installations are not, then, as Thelma Golden has claimed of Walker's work, "the slave narratives that were never written,"[36] for

they do not presume that relation to the real that is history, even as they depict its perverse realities. Nor do they presume to speak from that time, from that past, even as they make use of a set of antiquated, and thus, for that history, contemporaneous forms. Their temporality is other. The story told in *Gone* is not, as in Randall's work, offered from the point of view of a slave on the plantation. Nor is it, as in Morrison's novel, depicted from a position of authorial omniscience. Instead, the story, if it is indeed a story and not an assemblage of unrelated fragments and visual vignettes, emerges from between "the dusky thighs of one young negress and her heart," from a position of difference and desire, the difference and desire of one young negress *in the present*, namely, the contemporary African-American artist Kara Walker. If her authorial relation to the "young negress" named in *Gone* is less than explicit, elsewhere Walker inserts herself quite self-consciously into the work, either textually (in the panoramic *Presenting Negro Scenes Drawn Upon My Passage Through the South and Reconfigured for the Benefit of Enlightened Audiences Wherever Such May Be Found, By Myself, Missus K. E. B. Walker, Colored*, 1997), visually (in the self-portrait [of sorts] *Cut*, 1998),[37] or performatively (in the 2004 Fabric Workshop performance/installation *Fibbergibbet and Mumbo Jumbo: Kara E. Walker in Two Acts*).[38]

If, to return specifically to *Gone*, a "historical romance" emerges from "between the dusky thighs of one young negress," from between the dusky thighs of artist and artistic persona that is Kara Walker, then history's representation is presented and put forth here, as something of a natal process: artwork as offspring. Although such a possibility here proposes a rather essentialist, maternal model for artistic creation— the (female) artist birthing these "historical romances"—elsewhere Walker positions herself as more of a child, speaking of her "constant need to suckle from history, as though history could be seen as a seemingly endless supply of mother's milk represented by the black mammy of old," her "fear of weaning," and her sense of progress "predicated on having a very tactile link to a brutal past."[39] (Walker may be said to represent this image of suckling most forthrightly in the striking figural group—three women and an infant, linked mouth to breast— centering her *The End of Uncle Tom and the Grand Allegorical Tableau of Eva in Heaven*, 1995, if not elsewhere in her oeuvre.[40])

Whatever the relation of Walker's work to metaphors of maternity and natality, what *Gone* suggests is that if that relation to "a brutal past" is even perversely nourishing (and one might think here of Paul Celan's lyric evocation in "Fugue of Death" of the smoke of the death camps— "black milk of daybreak, we drink you mornings, and evenings, we

drink you"), what it sustains is something other than life. Using a bodily metaphor for the burden of historical trauma that invokes carrying, not so much a child, as a disease, Walker has stated, "History is carried like a pathology, a cyclical melodrama immersed in artifice and unable to function without it."[41] And it is then perhaps not surprising that what emerges from this traumatized, pathologized body, from between the "dusky thighs of the young negress," is the legacy of that history, given visual form, the resolute blackness and stasis of the silhouette, the return of the repressed, the sublimated, materialized in and by the ghostly trace of the inert "black art" that concretizes not presence, but absence, not so much a stillborn child, as something undead, a ghost.

* * *

In his catalog essay for the 2003 exhibition, *Kara Walker: Narratives of the Negress,* Darby English suggests that in her *Before the Battle (Chickin' Dumplin')* 1995 (figure 14), Walker "implicitly insinuates" herself into Pliny's myth of the origin of painting.[42] And while I certainly agree with English that Walker's silhouette practice as a whole bears an interesting and quite manifest relation to this antiquated strategy and its mythic site of textual origins, and that Walker establishes a very self-conscious relation to her subjects, I would suggest that the temporality of this work in particular, and Walker's work more generally, is significantly different. And this difference in temporality, one that is already manifest in the authorial framing of *Gone,* allows us to understand something of the relation of Walker's work to history, and the historical epoch her work might be said to represent.

Certainly, the title of the piece, *Before the Battle,* stakes its claims to a time before. The title may well be a rhetorical echo and assertion of a particular instance of anteriority, namely, the Corinthian maiden's act of pictorial inscription in the moment before her lover's departure. If so, this piece, and Walker's work more generally, in fact establishes a very different relation to the lost object. For Walker's work is, of course, done not before the battle, but after, many years after. It is done after the historical battle, or series of battles, for emancipation, from the nineteenth-century battle of the civil war to the twentieth-century struggle for civil rights. It is done, with all the weight of the temporality of trauma, from a position of inheritance, and of belatedness.

Moreover, visually and artistically, Walker's work is also done after. It is not a point of mythic origin, from which a history of visual representation will follow. Rather, Walker's silhouettes are created after a series of significant advances and milestones in a history of visual rep-

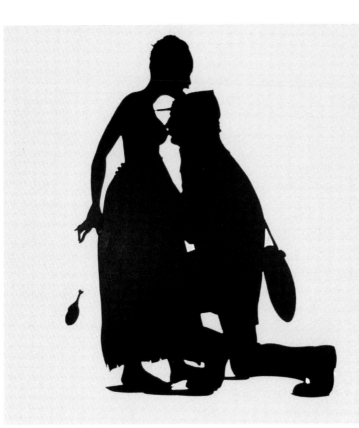

FIGURE 14 Kara Walker, *Before the Battle (Chickin' Dumplin')*, 1995. Cut paper on canvas. Courtesy of Sikkema Jenkins & Co., NYC.

resentation. That is, they are done well after the silhouette had achieved its place in a history of eighteenth and nineteenth century visual culture and then fallen into disuse, supplanted by ensuing techniques and technologies of visual representation, photography foremost among them. And, perhaps even more important, Walker's silhouettes are conceived long after the history of modernism and the achievements of the historical avant-garde—remember the call of another work of cut-paper, Picasso's 1912 cubist collage, *Guitar, Sheet Music and Glass,* newspaper fragment bearing the words "Le Jou: La Bataille s'est engagé!"—gave way to the postmodern, in all of its self-proclaimed posteriority.

The relation of *Before the Battle* to its lost objects is not one of anticipation but, instead, one of explicit and inevitable belatedness. That is, *Before the Battle,* even as it attends to the historical moment "before," representing as it does the antebellum South and taking up the antiquated representational strategy of the silhouette, shares none of the

anticipatory modality or anteriority of the Corinthian maiden's tracing of the silhouette of her soon to be departing lover. Walker's work forthrightly and necessarily comes after, its sense of urgency precisely in its delay. It is a representational act that shares its temporality with the writing of history and the construction of memorials, even as it partakes of neither their methods nor their materials. Markers of lost bodies, Walker's silhouettes create narratives without narration, memorials without monumentality, and, perhaps most important, figural form without the figure.

And that absence of the grounding figure, that human presence upon which the indexicality of the silhouette is predicated, is perhaps the most important point about Walker's revival of the antiquated practice. For Walker's silhouettes are not, in fact, done before a body in the studio. Which is to say that they are not, in fact, silhouettes, at least not in their functional relation to the process of creation and the presumption of a body. For all of their miming of the form of the silhouette, they do not reproduce its technical function. No one stands before a raking beam of light. No one's profile is captured. There are no historical tableaux created in studio. These silhouetted figures are neither trace nor tracing. Instead, these silhouetted figures emerge from and concretize the bodies that haunt the historical imagination and its contemporary inheritors. The material fact of these cut-out images is not the body as depicted through the visual strategy of the silhouette, but instead, the body as understood through the social system of the stereotype.

Emptied of any claims to the indexical, to a relation of physical contiguity, Walker's silhouettes establish an indirect and oblique relation to the historical figures, historical bodies, and historical trauma they take as their subject. In Walker's work, the index emerges as a form rather than a function of representation, as a point of reference rather than a referential structure of representation, as a vestige rather than a viable means of representation. These silhouettes are not done before a body, that is, in front of a body posed in the studio. They are done after, away from the bodies, long after the historical trauma they take as their subject. No longer establishing its claims to real bodies, Walker's work nevertheless stakes its claims to the past, to something we might call history.

Walker's images are not documentary but instead, supplementary, marking history not from a position of witness but from a position of posteriority and distance. As previously mentioned, sharing their temporality with both the writing of history and the work of memorial,

Walker's work is a necessarily retrospective encounter with the past, with what remains. It is a working through of the past, as passed, even as that past haunts the contemporary imagination. Unlike, say, the images that structured the 2000 exhibition at the New York Historical Society, *Without Sanctuary: Lynching Photography in America*,[43] the horror of Walker's work is precisely the degree to which it reflects not the historical reality of slavery but instead, the cultural imaginary in its aftermath. Where *Without Sanctuary* confronted contemporary audiences with its graphic images not just of lynching but of the crowds of leering white spectators gathered to witness the act of atrocity as visual spectacle, the documentary photograph, in this instance, both an unequivocal record of cruelty and an unabashed form of its celebration, Walker's work gathers its force precisely for its relation to obscene fantasy, even if that fantasy is predicated on precisely such an obscene historical reality.

The shock of Walker's images, then, is the way in which, for all of their structural and temporal remove from history and its embodied subjects, for all of the ways in which they are profoundly, manifestly, anti-indexical, for all of their obvious fictions and fantasy, they seem hauntingly vivid, if not, of course, real. Combining the antiquated representational strategy of the silhouette with the inherited social symptom that is the stereotype, each predicated on the reduction of the human subject to a recognizable form, Walker's unreal bodies return from the realm of the apparitional and spectral to take hold of history and give it material form in the present. And even if it is not "history" that we recognize in Walker's work, the project of history here invoked as some notion of the recuperable real, we are stopped by these works, arrested before them, precisely for how they activate the legible legacies of slavery, for how they call forth the forces that haunt an American nation and imagination.

* * *

To the extent that silhouette and stereotype share an epistemological dependence upon legibility, that is, to the extent that both the silhouette and the stereotype are predicated upon recognition, what might otherwise remain purely in the realm of the phenomenological, the perceptual (think, again, of Gombrich's duck/rabbit) rises into the realm of the social, the political, and, in the end, the ethical concerns of the present. For if recognition is at stake in the visual representation of the human form, of the human subject, if it is only in and through

recognition that a portrait coalesces as such, it is also in and through recognition that a human subject achieves political legitimacy, which is to say, a place in the social order. To recognize is to acknowledge, socially and politically, the other, it is to grant to the other equal rights.[44]

If in recognition inheres the utopian possibility of equality, then recognition, even when it, as perceptual and social act, identifies difference and calls up a history of inequality, it also holds within its activity the possibility of political progress. That Walker's work hinges on recognition is then significant, even as she produces what many consider "negative images." That she conjures up, materializes, the repressed bodies of history, the obscenities of the institution of slavery, is not the only function of her work. She is neither the first nor the last to give visual form to atrocity, to depict the violence and violation, the subjugation and servitude, the dehumanization and degradation that structure a history of race and race relations in America. What is noteworthy, then, is not that she represents that history, but how she represents that history. That she materializes this history through two forms predicated on structures of recognition—the silhouette and the stereotype, is where and how her work gathers both its potency and its potential.

As spectators, we are forced to acknowledge that we recognize not only those horrific depictions of violence, but also, those vivid and enduring stereotypes of race. There is no room for disavowal here. The force of Walker's work is precisely the degree to which her forms, as antiquated as they may appear, remain entirely contemporary; they play on a set of cultural images that remain utterly legible in the present. Where Fred Wilson collects and displays in museum vitrines (and David Levinthal collects and photographs) the incriminating vernacular evidence of a postemancipation history of inequality, discrimination and prejudice, where Spike Lee makes of such American cultural markers as minstrel shows and racist memorabilia a film like *Bamboozled*, Walker fully avoids the actual trace of the real, archival or material, emptying the indexical function of the silhouette and using it solely as artistic form. Instead of the trace of the real, she offers, as and in the form of the silhouette, the trace of the imaginary, both the darkest fantasies of sexual violence that haunt an American imagination and the very category of the stereotype, that utterly abstract yet enduring form. That we recognize these forms, these stereotypes, that they are legible to us, now, still, demonstrates that even as we fall back into patterns of recognition that would seem to repeat and thus perpetuate the very stereotypes and structures of discrimination and inequality they support, Walker's "negative images," in the shock that their scenarios

induce, may well prompt us to consider not just history, but its legacy in the present. (And, moreover, that her recent installations deploy light and projection in such a way as to include our shadows amidst those concretized on the gallery walls, furthers the degree to which we are implicated, as spectators, in the depicted scenarios.) Negative images that are, in the end mnemonic devices Walker's silhouettes activate not just historical memory, but its trace, a trace that haunts the American nation, namely, the stereotype, which, like the silhouette, is at once utterly without substance and yet remains stubbornly, intractably present.

* * *

William Kentridge is a South African artist whose work may be said to bear a similar relation to his nation's traumatic history of racial oppression, his animated films of a recurrent cast of characters in the penultimate moments of apartheid and its aftermath—from European-Jewish exile to indentured black subject—a form, like Walker's, not of exorcism, but of persistent exploration and interrogation. Charcoal drawing as a process of marking, reworking and erasure, questions of history and memory, the decimated South African landscape and cities, its human inhabitants and inheritors, all are in a constant state of flux, the Freudian model of the wax tablet or the literary form of the palimpsest as the basis for an aesthetic, and, in the end, cinematic practice. Rosalind Krauss theorizes that in Kentridge's adoption of this singular animation technique, one that would seem to instantiate the delay and distance from its ostensible subject, he forges a new medium.[45] I would suggest, however, that we find in Kentridge's avoidance of a monumentalization of memory less a new visual medium than a new mode of historical encounter. Kentridge's charting of the belated development of democracy in South Africa, through the figures of Soho Eckstein (the dark-suited industrialist, whose image has been said to be predicated on a linocut Kentridge made in his youth from a photograph of his grandfather in a three-piece pinstripe suit) and Felix Teitlebaum (the always nude alter-ego of the artist), is a visual mode of addressing his nation's traumatic history. Kentridge's body of filmic works—*Johannesburg, 2nd Greatest City after Paris* (1989), *Monument* (1990), *Mine* (1991), *Sobriety, Obesity & Growing Old* (1991), *Felix in Exile* (1994), *History of the Main Complaint* (1996), *WEIGHING . . . and WANTING* (1997), and *Stereoscope* (1998–99)—not only stage the personal struggles of their recurrent characters, but also represent the struggles of a nation as it moves from

a system of apartheid to the electoral victory of the African National Congress in the first free national elections in 1994, to the subsequent proceedings of the Truth and Reconciliation Commission.[46]

If Kentridge has described the situation in South Africa as a struggle between the forces of forgetting and the resistance of remembrance, between amnesia and memory, or, in his words, between "paper shredders and photocopying machines,"[47] his work, both in its thematic preoccupations and its very material existence, stands firmly on the side of the production of memory. But if Kentridge's work is, for all its idiosyncratic reliance on charcoal drawing as the basis for filmic production, fundamentally cinematic, a recent piece makes clear its relation to earlier forms of visual culture, to the shadows and shadow plays of more antiquated visual practices. It is thus that I turn to Kentridge's 1999 *Shadow Procession,* which, as opposed to his standard practice of altering charcoal drawings, is composed entirely of torn paper cut-outs and found objects, and, as opposed to the mise-en-scène of his earlier filmic works, brings crowds and processions to the representational fore (figure 15). A film in three parts: the first accompanied by accordion and voice of Johannesburg street musician Alfred Jakgalemele joined in a song of grief and lament; the second, the continued procession of the figures to a much livelier tune, a jaunty version of "What a Friend We Have in Jesus," procession now a kind of dance; and the third, dance given over to a fully random and violent form of movement, frenetic figures joined as well by an actual cat and an eyeball, looking left and right. *Shadow Procession* depicts row after row of refugees, in the first downtrodden and burdened by material possessions and history, in the second, animated, if not dancing and fully celebratory, and in the final sequence, utterly anarchic, moving toward a future that they (and we) do not yet know.

What is particularly interesting about *Shadow Procession* is not only what it depicts, an unending stream of the displaced and disinherited of South Africa. Rather, it is remarkable that Kentridge realizes the filmic representation of the dispossessed solely on the basis of simple paper cut-outs and found objects (scissors, gramophone speakers, tripods), photographed as they are shifted across a translucent surface. In a deliberate return to an artistic practice that repeats the conventions of a children's game before a lamp, in which fingers and hands can create birds, rabbits, ducks and the like, Kentridge produces the procession as a form of what he terms a "practical epistemology,"[48] that is, picturemaking as realized in and through recognition. An optical interruption of light, the figurative forms that we recognize in shadow play (or

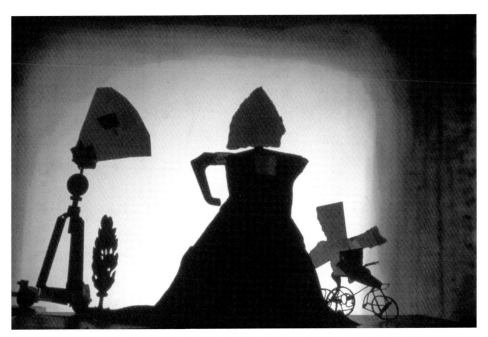

FIGURE 15 William Kentridge, *Shadow Procession,* 1999. Animated film, 35 mm film, video, and DVD transfer, 7'. Courtesy of the artist and Marian Goodman Gallery, New York.

Shadow Procession, for that matter) are, as Kentridge himself muses, not the result of the willing suspension of disbelief, but rather, of the "unwilling suspension of disbelief," which is to say, that we are power-less to stop ourselves from being fooled. Such a perceptual response to shadow play and shadow form, to silhouette, is not an act of gen-erosity or willingness, but simply what we do, an act of recognition. Of course, as children, part of the delight of such playing with shadows is that we know we are being fooled, we know it is at once a hand and a rabbit, we shift between reality and illusion, performer and performance.[49]

If Kentridge's work allows itself this element of play with recogni-tion, so too, in the end, does Walker's. The "ethics of spectrality" that I claimed for Walker's work at the outset of this chapter, then, is not only the relation her work establishes to history and its subjects, the oblique and necessarily belated encounter with a traumatic history of a nation that her simulated silhouettes structure. Rather, the ethics of spectrality is also, necessarily, the relation her work establishes to those forms that haunt the American psyche, the "shadows of history," that is, the degree to which her work forces us to confront, through the acti-vation of stereotype, not just our nation's ghosts, but our own. The

ethics of Walker's work lies not only in its historical or memorializing impulse, that is, in its persistent return to the history of the antebellum South, but in its forms, in its return both to the silhouette and, despite what Saar and other critics may say, to the stereotype. For in reimagining and reanimating these antiquated, spectral forms, Walker's work demonstrates that what may well be considered past, has by no means passed away, and indeed still structures our perceptual and social economies in the present.

It was through the service of that same earth that modeling portraits
from clay was first invented by Butades, a potter of Sicyon, at Corinth.
He did this owing to his daughter, who was in love with a young man:
and she, when he was going abroad, drew in outline on the wall the
shadow of his face thrown by a lamp. Her father pressed clay on this
and made a relief, which he hardened by exposure to fire with the rest
of his pottery; and it is said that his likeness was preserved in the
Shrine of the Nymphs until the destruction of Corinth by Mummius.

PLINY THE ELDER

In 1995, the British twins Jane and Louise Wilson completed a piece called *Crawl Space* (figure 16).[1] As is typical of the architectural sites featured in their cinematic scenarios, the Victorian house depicted in the Wilsons's *Crawl Space* is abandoned, bereft. Signifiers of dereliction abound. A worn midcentury modern chair stands in the center of one room, the lone survivor of an era other than the house's historical origins, a trace of one of the successive generations of inhabitants who once dwelled within its Victorian walls. In other rooms, the floors are strewn with trash or piled with discarded appliances, debris and disrepair yet another sign of the passing of inhabitants. In the kitchen lie the collapsed remains of a sink. In another room rests the mangled armature of a fan. With repeated shots of peeling paint, faded wallpaper and sagging insulation, the camera documents and depicts a home that has given way to the temporality of neglect. Its status is now that of the ruin. Uninhabited because it has become uninhabitable, uninhabitable because it was uninhabited, in *Crawl Space,* notions of cause and effect are fundamentally suspended. Entropy is now the governing logic of the domestic space as it gives itself over to the forces of nature.

But if entropy governs the overall space of the ruinous domestic interior, what *Crawl Space* dramatizes is how another force operates as well. This is a building that has become, through its abandonment and dereliction, literally *unheimlich*. That is, for all of its recognizable elements, in its forsaking by its former inhabitants, the Victorian structure is both no longer, and no longer *like,* a home. The physical space of the home has returned to being only, merely, an architectural type as opposed to an actual residence; it is now simply a house. But it is unhomelike in another sense as well, namely, psychological or affective.

FIGURE 16 Jane and Louise Wilson, *Crawl Space*, 1995. 16 mm film (U-matic, 9 mins, loop) 335 × 427 cm. Courtesy of Lisson Gallery and the artists.

Familiar yet frightening, the domestic architectural space that is the site of *Crawl Space* is a space of something that was once a home, something that was literally homelike, transformed into something that is decidedly not. Rather than a place in which to settle, to reside, this house is a space that unsettles. For the house in *Crawl Space* reveals itself to be a psychological space of the *unheimlich,* of the uncanny.[2] In short, the domestic architecture depicted in *Crawl Space* is the irrepressibly haunted house, the home laid bare as its other, its antithesis revealed as its essence.[3]

And the Wilsons do not leave it at that, haunting as mere suggestion, cinematic intimation. For despite a series of establishing shots that would seem to bear witness to its utter abandonment, ensuing scenes make manifest that something other than the filmmakers' energetic movements animate this dreary and desolate interior, even if not in the form of the familial life or domestic activity that once may have enlivened its interior. After but a fleeting glimpse of an overgrown lawn, the camera crosses the threshold of the house once and for all, its subsequent operations limited to the space of the interior. Upon entering

the house, the camera begins its exploration of the abandoned domestic space, lurching down narrow hallways, climbing and descending stairwells, panning across the empty rooms of the former domicile. At first, the restless gaze of the camera reveals nothing other than signs of abandon—the peeling paint, the fading wallpaper, the piles of discarded belongings. But shortly thereafter, certain details begin to interrupt these shots of neglect and decay. An audio component introduces the sound of a heartbeat. Doors slam, in rapid succession. Footsteps resound. A lifeless object thuds against the wall and leaves a bloody trace. The cat-suited sisters, the twin filmmakers, are not alone. Someone, some thing, inhabits and haunts this interior, this architectural space, this uncanny place, this site of domesticities past.

Steeped in the visual codes and conventions of the genre of the horror movie, *Crawl Space* produces a vision of this house that is no longer a home but rather a crude yet mesmerizing neo-Gothic nightmare.[4] Part parody, part pastiche of horror films past, from *The Exorcist* and *Carrie* to *The Shining, Crawl Space* produces a vision of a house that has been transformed from a place of shelter and nurture to a site of menace and danger. As a genre, one might say that the horror film unabashedly exploits the traumatic potential of the visual field, deploying techniques that blur, if not level, the distinction between real and paranormal, animate and inanimate, live and dead. In such films, it is often the case that a body that has been buried (if not also repressed) returns from the past and from the dead, haunting the present with a vengeance. Predicated on the genre of the gothic novel, the horror film makes visible the body of literary invention, the body that literature could conjure only obliquely, through words and the sheer power of the imagination.[5] A specter, a ghost, an apparition, quite literally, an absence made present, the horror film gives back to the domain of the visual a body whose radical non-being defies the very notion of representation, even as it appears in cinematic form. Indebted to the mechanism of haunting, the metaphor of haunting, the horror film represents and re-members the unrepresentable body, the body at once ghastly and ghostly. For it is the horror film that gives the absent and unrepresentable body back to the domain of the visible, to the realm of representation.

What haunts this domestic interior? Just what is it that the Wilson twins' camera makes visible? Certainly, an anxious atmosphere pervades the film from the outset, intimated even in the establishing shot. That shot depicts a woman, clad in a black leather cat suit, completely submerged in a bathtub full of water, Emma Peel as Ophelia, Ophelia as Emma Peel. From her mouth emerges a bubble, in which we see, trapped, imprisoned, her reflection, her double, her doppelgänger, if

not her actual twin. This woman and her double will appear at intervals throughout the film, playing out sinister, somewhat sadomasochistic games of entrapment and confinement within its rooms, upon its stairwells, in its attic. For despite their free play, they remain confined within the walls of the Victorian interior. This house that is no longer a home has taken on the constrictive and restrictive dimensions of the eponymous crawl space.

That metaphor of confinement, that state of confinement, is underscored in the film's final shot, in which the entire cinematic mise-en-scène is displaced onto the female body with a final close-up of the leather-clad figure's exposed abdomen (figure 17). Bathed in the glow of a rhythmically flashing red light, in the closing shot, the female body becomes a site of inscription. Etched upon her skin, incised upon her flesh, knifed above her womb, is the title of the film, "crawl space," the word made wound. The semiotic wound establishes the female body as a crawl space too. A vessel, a space of cavities, passages, canals, the female body is marked, inscribed as an analogue for the house, repeating a convention of the gothic novel, and the women's novel, in the late nineteenth century.[6] The womb as room, the womb as tomb, the body, now a bloodied text, marked and marred, its biological function identified, made legible upon the parchment that was and is her skin.

If that doubling of body and room, body and tomb, concludes the film loop, that doubling or collapsing of the architectural edifice and the female body also pervades the film as a whole. The analogy is explicitly established through the one recurring shot in the film, a shot that has particular import for its staging of the conflation of body and building. Shortly into the film, the camera fixes its gaze on a wall, treated with floral wallpaper, which, it is soon revealed, is animated by more than the decorative pattern embossed on its surface. There, the roving lens reveals a strange and straining bulge. It is the presence of a human form, the contours of a female figure, a body that presses and writhes against the walls of the house, struggling to get out, or, if nothing else, to make itself known, visible, through the assertion of an impression, an imprint, a trace, a mark.

As the film continues to depict the twin cat-suited figures, playing out their sadomasochistic games of bondage and submission within the confines of the house, the film cuts back, two more times, to this scene of female confinement and entrapment. The body remains within the walls, imprisoned behind the scrim of wallpaper, trapped behind a vivid signifier of bourgeois domesticity, of craft, of the decorative, of the feminine.[7] Entombed, encrypted within the walls of the home, the female body struggles against the patterns, the strictures of domestic-

FIGURE 17 Jane and Louise Wilson, *Crawl Space*, 1995. Courtesy of Lisson Gallery and the artists.

ity, those constraints literalized and visualized in the wallpaper hung upon the plaster walls, which produces something like an architectural mummification, dry wall as full body death mask.

With its various and repeated images of bodily confinement, submission, and subjugation, the film squarely equates the (historical) situation and experience of domesticity with an abdication of autonomy that approaches incarceration. Through its scenarios and recurrent images, the film dramatizes the degree to which the anticipated material and emotional rewards of marriage and maternity were often displaced by the enormous costs to both body and psyche. Further, in its activa tion of the very structures of the house itself, the film puts forth a vi sion of domestic architectural space as complicit in the cultural construction of a normative female subjectivity.[8] Thus, even as *Crawl Space* mobilizes utterly generic codes in its neo-Gothic restaging of the terrors and travails of domesticity, the film gives cinematic form to a very specific historical situation of bodily and psychic repression, a situation that continues to haunt the present.

With its ruinous and haunted mise-en-scène, *Crawl Space* conjures from its place in the present an identifiable domestic past, namely, a

late nineteenth-century past in which not just writers, but women writers explored the topography of the home, revealing its latent horrors. Indeed, in its imaging and imagining of the spaces and places, the dramas and traumas, of domesticity, *Crawl Space* might be said to visualize and name not just something of the domestic interiors that defined many of the houses of late nineteenth century London, but, indeed, something of the situation of domesticity and domestic confinement that once defined that era. It is a site and situation that saw its depiction in one particular literary text, namely, Charlotte Perkins Gilman's "The Yellow Wallpaper."

Published in 1892, "The Yellow Wallpaper" was the work of a woman who would go on to become one of the earliest feminist advocates for a different kind of domestic architecture, one that would not exploit women's domestic labor and instead allow for its recognition and remuneration. The tale not so much directly prefigures as more generally predicts the political awakening of a woman writer who would go on to advocate for houses without kitchens, neighborhoods built around cooperative childcare and towns without the usual separation between public and private spaces. Perkins Gilman's opposition to traditional domesticity and her awareness of the perils of domiciliation may be seen to structure even this early tale of a rest cure gone terribly awry.

Crawl Space is haunted then, not only by the body of a woman, trapped behind the very walls of her domestic confinement, but by the literary text that structures its narrative impulse and visual iconography. It is thus that *Crawl Space* comes to serve as a cinematic palimpsest through which the very situation of domesticity is rendered visible, through which that historical condition of domiciliation as a kind of house arrest, is rendered concrete. As such, *Crawl Space* may be understood to stand as an uncanny cinematic restaging, if not a fully articulated appropriation, of that foundational feminist tale of confinement and liberation, reading and misreading, doubling and reflection, madness and insight. Moreover, *Crawl Space* may be understood to have given monumental cinematic form to a much more recent representation of the domestic domain, namely, Rachel Whiteread's *House,* which had only just been dismantled by a team of bull-dozers and front-end loaders when the Wilson twins began working on their piece.

* * *

The Victorian row house from which Whiteread's *House* took its form, a modest, three-story structure at 193 Grove Road in the Bow neighborhood, had been slated for demolition, yet another phase in a series

FIGURE 18 Rachel Whiteread, *House*, 1993. Courtesy of the artist and Luhring Augustine.

of transformations of London's East End, Canary Wharf the most prominent example (figure 18). Long occupied by ex–dock worker Sidney Gale and his family, the house, like others of its era and type in working-class neighborhoods throughout London, had by the early 1990s found itself on a council list of condemned properties. In 1992, when Whiteread formally undertook her project, the terrace house at 193 Grove Road was the last of its block standing, Gale having refused to leave the premises, despite the extensive demolition work around him.

Of course, Whiteread's artistic intervention did not avert or even forestall Gale's displacement from his long-standing place of residence. For her goal had never been to save the imperiled house for its tenants. Nor did her artistic intervention prevent the subsequent demolition of the terrace house. For her intention had also never been to stabilize or maintain the structure as some kind of relic or museal reminder of a generally enduring architectural form and urban housing type. But her artistic intervention did perform, even if only briefly, a peculiar act of preservation, of commemoration, of remembrance. For her project was and had been, from the very first moment she began scouting for a site with James Lingwood of the Artangel Trust, to cast, in concrete, the entire interior of a condemned Victorian terrace house.

With the destruction of *House,* a conclusion that was at once anticipated in its planning and yet seemed to follow directly from months of heated public debate and opposition, the site-specific sculpture that had transformed void into volume, space into substance, emptiness into edifice, absence into architecture, was reduced to a pile of rubble.[9] With the dismantling of *House,* a monumental sculptural form that had arrested a moment in British vernacular architecture simply vanished from the urban landscape. And with that, a vestige of housing for the working urban poor, a trace of the domestic domain of women, was doubly extinguished, both terrace house and its inverted death mask, home and its eerie double, rendered nothing more than a handful of dust. Or was it?

As a cinematic intervention into the period architectural type and domestic interior temporarily preserved in Whiteread's short-lived but much-publicized public art project,[10] the Wilsons' *Crawl Space* gave to *House* a certain perpetuity. Furthermore, the Wilsons' film might be said to have made visible that which remained invisible in the cement form, the concrete phantom that was Whiteread's project, offering a glimpse of all that might be said to have remained temporarily encrypted within Whiteread's minimalist mausoleum.[11] For where Whiteread's work had offered up, only to wall off and entomb the Victorian interior at 193 Grove Road, the Wilson twins' piece made visible all that had remained unrepresented in its sculptural antecedent. As opposed to Whiteread's obdurately impenetrable massing of liquid turned solid, a sculptural instantiation of thwarted movement, and in turn, of blocked entrance, of voyeurism foreclosed, the Wilsons' camera penetrated and relentlessly explored every corridor and cavity of the derelict domicile they took as their subject, her subject.

The lacunae of history redressed in the present as sepulchral sculpture, as absence made substance, Whiteread's work may be said to stand as something like a mute monument to a bygone era, to a moment when the domestic was a place of domiciliation. As generic as her subjects may seem, Whiteread's work is remarkably consistent in its historical specificity. Nowhere in her oeuvre do we see the objects of the present, either the information and communicative technologies of radio and telephone, television and personal computer that opened up the space of the domestic to the world beyond, or the innovative conveniences of refrigerators, washing machines, dish washers, and microwaves that, over the course of the century, have redefined the labors of domestic life. Instead, we see pedestal sinks and claw-footed tubs, tables, chairs and mattresses, her work attending and attesting to the

simple objects of that earlier era, her casts bearing witness to that time before, when the travail of domesticity was the plight of many women.

In addition to these variously antiquated objects of everyday life, Whiteread also cast their contexts, that is, the very spaces and enclosures of domesticity they once inhabited. It was thus that she cast not only floorboards, closets, and staircases, but even an entire room, a Victorian bed-sit, pointedly titled *Ghost* (1990). And, as the lost project *House* (1993) attests, such work culminated in her casting of an entire Victorian terrace-house. Whiteread's subsequent work, increasingly commissioned rather than individually and independently conceived, has taken on other architectures, from the ubiquitous but somehow invisible urban forms of the water towers in Lower Manhattan,[12] to the lost synagogues and their former worshippers in a postwar Vienna.[13] Yet, even if these later works may be seen as a departure from her very first castings of a closet, a floorboard, a bed, a tub, they are not. For no matter the scale nor the site of her work, it has generally maintained a strict relation to the spaces of domesticity,[14] whether through her attention to the water towers that sustain the fluid mechanics and dynamics of urban dwellings throughout the city or to the private libraries that sustained, if not outlived, a community structured by a deep and abiding belief in the word and the book.

Furthermore, from the outset, Whiteread's work has maintained a strict and consistent adherence to the technique and technology of casting, even if only to adapt and invert the process to allow for the concretization of negative space. Insistently engaged in the affective dimensions of both architecture and the objects of daily life, her work manages to convey something of the situation of subjects who once dwelled and labored within the space of the home, even without representing them. A materialization of absence, of all that was not matter, of all that did not matter, her work uses the antiquated technology of casting to remember, even if not to re-member or re-present, the lost subjects of a vanishing domestic and specifically urban history. Insistently figurative yet devoid of the human figure, Whiteread's work remains dedicated to somehow marking life, if only through an instantiation of its aching and irredeemable absence, each sculptural work something like a cenotaph and inverted death mask in one.

* * *

If casting expanded the material possibilities of sculptural practice and production, allowing sculptors to produce models and molds in highly

malleable substances like plaster of paris, clay, or wax before making a final cast in a durable material like bronze, casting also introduced and authorized in sculptural practice the possibility of reproduction. Neither additive nor subtractive, casting operated according to the logic of the duplicative. Along with this logic came certain functions. Sculptural casts served both as a link to antiquity, that is, a means of preserving and disseminating its sculptural and architectural history, and also as a technology with which artists could produce their own work in multiples.

The possibility of multiplication (along with fragmentation and random grafting) afforded by the casting process was, for Leo Steinberg, what allowed a sculptor like Auguste Rodin to subvert the figurative sculptural tradition, as inherited from the Renaissance and antiquity.[15] Following on Steinberg, Rosalind Krauss demonstrated in an essay that is as much about modernism and its mythic claims to originality as it is about Rodin, that Rodin's bronze casting ultimately introduced the possibility of reproduction and multiplicity at every point in his sculptural practice and process, thoroughly undermining not simply the status of figurative sculpture, but the very ontological and epistemological status of the artistic category of the original.[16] Following on Steinberg and Krauss, among others, Georges Didi-Huberman also pursued the case of casting in Rodin, part of a broader, more sweeping argument about the foundational and fundamental relation of death masks to sculptural practice and its theorization in the nineteenth century, that is, at the origins of artistic modernism.[17]

To say that casting mortifies its subject, then, is only to underscore its grounding relation to the process of making death masks, those posthumous portraits of the human subject. When Pliny's Corinthian potter went on to cast a likeness from his daughter's tracing of the shadow of her departing lover, he deployed a technology that offered the possibility of a certain physical presence and place, if not, in the end, eternal remembrance. Pressing the silhouette with clay, hardening the relief by exposure to fire, the potter used the fires that had once projected the ephemeral shadow upon the wall to create a more permanent sculptural object. In sculpting and casting from that profile, the potter sought to materialize something of the absent body, giving three-dimensional form to his daughter's pictorial, and memorial, endeavor. In creating a sculptural piece destined for preservation in a shrine, in casting a solid form from the linear contour of his daughter's drawing, the Corinthian potter ultimately produced something like a death mask for the lost beloved, albeit in absentia, that is, albeit from the silhouette and not the actual subject.

A process that dates back to the plaster (gypsum) masks of ancient Egypt and whose prototypes may be found in the funerary monuments, and funerary practices, of ancient Rome, the process of casting death masks was revived in fifteenth-century Europe as a means of allowing for the body of the monarch (as mannequin) to lie in state. Used during the Renaissance as models for statues of religious figures, by the late eighteenth century, the sale of copies of death masks of notable figures became a lucrative business.[18] A prephotographic means of creating memorial portraiture, the practice was popularized and dramatized in the work and waxwork collection of Madame Tussaud, whose first efforts in the medium were the death masks of such revolutionary subjects as Marat and Robespierre.[19]

An indisputably indexical trace of the human subject, the death mask was a means of bearing witness to a life that had already given way to death, granting eternal form to the evanescent body, the mortal coil, the human subject that in death becomes something other: a cadaver, a corpse, bodily remains. As opposed to the act of preservation that is mummification, the death mask is an act of substitution, of memorialization, a means of fixing an image of the deceased, capturing an impression of the face that it takes as its fugitive subject, portrait, and memorial in one. A two-part process, the making of a death mask involves the forming and then filling of a mold, producing, at one remove from its subject, a sculptural copy, a simulacrum of the face of the deceased.[20]

Of course, Whiteread's sculptural work, her casting of domestic fixtures, furnishings, and interiors, is and is not fully akin to the making of a death mask. Certainly, her materials revive those of the antiquated form, her work typically composed of either plaster or resin. And they certainly petrify and mortify their subject in a way that remains peculiar to the practice of casting.[21] But her subjects are not human, even if her work insistently attends and attests to the spaces of daily life, rendering its subjects, its objects, with something of the reverence and the relation established by the memorial process of the making of a death mask. Moreover, her method diverges from its fundamental logic and process.

For Whiteread's method arrests the process of making a death mask at its first stage. In Whiteread's work there is typically only one step, which would suggest that either there is no mold or cast. And following this logic, it would also suggest that there is also, in Whiteread's work, no "original."[22] Whether Whiteread thus makes of the original object the mold, or instead, produces the sculptural object as a mold that will never be filled, her work subverts the logic and interrupts the

process of the making of the death mask, materializing not the lost object (the deceased subject) but something equally, if differently, absent, namely, pure space, pure surround.

Whiteread's sculptural process thus inverts and short-circuits the casting process, resisting at the same time that it retains its methods and materials. And, as such, Whiteread's work insists upon its relation to absence, reproducing not a copy of the lost original sculptural form as compensatory presence, but instead, producing a sculptural form as pure materialized absence. The duplicative process of casting is taken up in the service of both replicating and instantiating the condition of unrepresentable otherness that is at once the traumatic and the uncanny. In taking on the spaces of domesticity, her work not only conjures up and concretizes that which was never there in the first place, namely, negative space—absence itself, that which was never matter—but more pointedly, that which never mattered: the history, the historical spaces, the historical operations of daily domestic life.

* * *

Whiteread's particular (in)version of the casting process is even more remarkable when carried out on a monumental scale, as was the case with *House*. Once transferred to the artist, the house on the Grove Road was transformed into a complex sculptural mold, its destruction only temporarily deferred as engineers found ways to execute Whiteread's ambitious program. After studying the property and the proposed project, the engineers of Atelier One and Tarmac Structural Repairs made and executed several recommendations. First, they shored up the foundation of the house to support the additional weight that would be borne by the casting process. And they treated the interior walls with a special delayed release debonding agent, so that the cast could eventually be freed cleanly from its architectural mold. Then workers began casting, spraying concrete through hoses onto a reinforced mesh screen. And layer by layer, level by level, the massive sculptural cast was gradually created from the ground up. In anticipation of that moment when the cast would fully fill the architectural interior, a hole was cut in the roof of the house, to be sealed only after the last worker had climbed out. The cut, the only means of egress, left no trace in the realized project, as the concrete fill was squared off at the ceilings of the top floor. The elision of the eaves and chimneys from the mold created the appearance of a rectilinear roofline. Finally, once the interior was fully cast and the concrete completely cured and hardened to produce a gunnite "shell" or "skin,"[23] the original house,

encased in scaffolding, was dismantled, room by room, outer wall by outer wall, and both the remains of the house and the scaffolding were removed from the premises. At once mold and chrysalis, by the end of the sculptural process, the house at 193 Grove Road stood no longer. But unlike its former neighbors, this house left behind a monumental reminder of its having been.

The *House* that emerged from the architectural chrysalis, the material object that remained, was a very particular permutation of the site-specific sculptural object,[24] and was Whiteread's first such sculptural project (figure 19). A casting of the space inside a derelict rowhouse, an impression of the aging walls of a Victorian interior, a revelation of something of the innards of the last of the Grove Road's terrace houses, the site-specific sculptural object that was *House* marked its relation not just to space but to place, to neighborhood. No longer a dwelling, a place of habitation, a site of domestic life, *House* stood as an eerie echo of its absent original, if not also, its urban environs.

A neighborhood that in the late nineteenth century was defined as much by its population of industrial laborers as by its industries, Bow came in the early twentieth century to witness an emergent movement of suffragists, whose political activities followed on the earlier local precedent of striking workers. It was also a neighborhood marked by destruction. During World War II, it was in Bow that the first bomb exploded during the air raids, the first V2 rocket landing only feet from the site of the house at 193 Grove Road. In the postwar period of reconstruction, Bow witnessed the influx of foreign workers, its changing demographics mirroring those of similarly displaced or diasporic communities established throughout London. By the early 1990s, when Whiteread undertook her project, talk of gentrification included plans for the creation of a common garden where the terrace houses once stood.

Built as it was of concrete, and not the brick and mortar of its lost object, *House* took on the material properties of the three concrete high-rises that towered beyond it and had augured since their construction the waning claims of the aging terrace houses to provide adequate urban housing for the working poor. Stripped of color, devoid of texture, the hulking grey form of the concrete sculptural edifice echoed the prefabricated stacked slabs of the social housing projects that had long since supplanted its form as a model of housing for the urban working classes. A brutalist bunker, a last stand, even if only memorial and not military, against the dual forces of urban renewal and gentrification, *House* bore a complicated relation to the terrace house it came to double, if not duplicate.[25]

FIGURE 19 Rachel Whiteread, *House*, 1993. Courtesy of the artist and Luhring Augustine.

Situated on its very footprint and formed upon its very foundations, the three-story structure that was *House* made voids solids and solids voids, inverting the architectural logic of presence and absence, the perceptual logic of figure and ground.[26] Such recessional forms and open elements as windows and bays, doorways and staircases, closets and fireplaces all protruded from the surface of *House,* space materialized. And in turn, what had extended into the space of the house now receded into the concrete, light switches, door knobs and locks but a set of cavities and holes, objects dematerialized. Even the textures of the peeling wallpaper and plasterwork saw their inversion in *House,* their patterns, if not their color, indelibly tattooed, along with nicotine stains and other sooty residues tattooed on its concrete skin.

Hardened skin a calcified shell, Whiteread's sculptural form articulates something more of its symbolic function, namely, its relation to the historical space of domesticity it takes as its subject. A shell in the natural world is a protective covering, a residence, a refuge, designed for the living creature contained within. In the case of the mollusk, the shell is exuded, extruded from its very skin.[27] What is protected in Whiteread's work is the most fragile of entities, the abstraction that is as well the lived reality of everyday life. As if the fetid air of the decaying domestic interior fossilized into form itself, the shell that is *House* might be said to preserve and protect not a living creature, but something of its former habitat. The patterns of daily life and its quotidian activity are stilled and arrested by the poured concrete, the lava of the (post)modern world, Whiteread's *House* something of the East End's fleeting glimpse of the destruction as preservation that was Pompeii or Herculaneum.

If the shell functions in nature as a space of protection and habitation, in the realm of culture, the shell is also its antithesis. For the shell is as well the empty framework, the architectural armature of a building either not yet finished or altogether ravaged by the elemental forces of weather, of fire, if not also the destructive forces of war or simply, time. What is at once protected and exposed, sheathed and revealed in a project like *House,* then, is the function and fiction of the house and home as a place of shelter and safety. The specific nineteenth-century terrace house whose disappearance from the contemporary urban landscape was arrested, albeit only temporarily, in the cured concrete of the gunnite shell of *House* is, as well, in its fortresslike bearing, the domicile rendered as a site of house arrest. Realized on the centennial of the publication of Perkins Gilman's 1892 "The Yellow Wallpaper," the specific yet generic house captured in *House* is the Victorian house that was,

at least for women, not so much a site of protection as one of containment, of hardship and confinement.

Furthermore, that in psychoanalytic terms, the shell is understood to represent the introjected site of a refusal, a refusal to mourn that holds within the topography of the psyche the inassimilable kernel that is the traumatic,[28] suggests its deeper structural significance. Concretized here in that shell that is Whiteread's inverted cast, in the shell that is Whiteread's interior of a Victorian house, is something of the domestic drama, if not, in some instances, trauma, through which modern female subjectivity was established, and, in many instances, utterly evacuated and effaced. Like a monument to an unknown soldier, Whiteread's sculpture marks and commemorates those subjects of history who bear no literal trace, who are not so much lost, as lacunae in the archives of modernity. Cast and exposed in the negative, the terrace house as prison house, the terrace house as fortress and bunker, the terrace house as hollow concrete monolith is also, at the same time, then, a massive mausoleum, a tomb, a cenotaph.[29] Whiteread's installation is a monument to a historical moment that, in its walling off and encryption, is at once forsaken, foreclosed, and yet, at the same time, somehow, fossilized, if not figured. *House* is a sepulcher that takes the form of a cast, a mold, an inverted death mask of a domestic domain that is concretized but, at the same time, never represented in and upon the calcified surface of its skin.

Whiteread's sculptural gesture couples an interest in absence with the material and metaphoric possibilities of the cast, using that form to enact a sculptural program that is emphatically, if obliquely, memorial. The cast, predicated as it is upon physical contiguity, is a mode of establishing continuity in situations of utter discontinuity. And yet, even as Whiteread's work literally touches walls, encases fixtures, fills doorways, and engulfs stairwells, it presumes not continuity and contiguity, but instead, contingency, precisely because its "original" is not present.[30] A materialization of space, of the void, of negativity, that is, of absence itself,[31] Whiteread's work is a marking of the absent body that once inhabited those spaces, once walked across those floors, climbed and descended those stairs, lay in those beds, sat on those chairs, soaked in those tubs, washed in those sinks, labored within those walls. As much as Whiteread's casting, then, is a way of making, if not visible, then visceral, something of these architectural interiors, it is also a marking, even if not a figurative representation, of the bodies: the subjects, the women, who once lived and worked in those rooms and in those houses. This relation to domesticity, to interiority, to ab-

sence, and, in the end, to the body that was not and cannot be repre-
sented, starts to render Whiteread's work the peculiar object that it un-
ceasingly is.

* * *

What, indeed, do Whiteread's sculptures represent? What is their re-
lation to their lost object? How do they at once mobilize and modify the
material trace? Certainly, Whiteread is by no means alone in the post-
war period in her return to the sculptural technique or technology of
casting. The indexical relation to (architectural) space that Whiteread
establishes in her castings through a materialization of the void has sev-
eral precedents even within a history of neo-avant-garde practice.
When in 1968, Bruce Nauman realized in concrete his Duchampian
idea of 1965 *A Cast of the Space under My Chair,* or when in 1969, Rich-
ard Serra flung molten lead against the junction where wall met floor,
each artist used aspects of the casting process to challenge something
about the very ontology of the aesthetic object. Moreover, each took
up a particular aesthetic process and challenged the fundamental logic
by and through which the aesthetic object might be constituted, each
insisting upon the cast as an aesthetic object in the absence of what
might once have been considered the original.

In his casting of the space beneath a chair, or, elsewhere, the space
between two boxes, Nauman played with the margins, the edges, the
limits, of sculptural form. Much as his contemporaneous video pieces
performed the bounding dimensions and spatial parameters of the stu-
dio, if not also those of the minimalist object and the body, through de-
marcated, highly circumscribed and repetitive movement, Nauman's
early sculptural pieces similarly concretized aspects of the phenomeno-
logical and the philosophical.[32] In his *Casting,* Serra found a means to
monumentalize and materialize not only space, but, perhaps more im-
portant to his project, the pictorial trace that was the abstract expres-
sionist brushstroke, with all of its claims to artistic activity, if not also
subjectivity. Serra produced a sequence of lead strips as both hardened
form and inchoate idea, the logic of the index and identity offered up
in a succession of displaced and repeated sculptural forms.

Certainly, this sculptural relation to the indexical put forth by Nau-
man and Serra in the 1960s saw its elaboration in the sorts of artistic
practices and architectural environments that so defined a body of work
in the 1970s: the rubbings of wainscoting and cracked plaster in the in-
stallations of Michelle Stuart, the reduction of an abstract pictorial ob-

ject to the status of mold or trace in the panel paintings of Lucio Pozzi, and the literal re-presentation of the building through opening its architectural armature for the excavation and revelation of its structure in the "building cuts" of Gordon Matta-Clark.[33] However, unlike these artists of the 1960s and 1970s, Whiteread's work does not insist upon establishing presence. Rather, it insists upon establishing absence, materializing it, giving it form, if not also, meaning.

Perhaps closer, then, to Whiteread's seemingly indexical interventions into irredeemable absences and the irrecoverable architectures of the commemoration of everyday life, domesticity, and domestic economies, is a project like Christian Boltanksi's site-specific *Missing House* (1990), one of eleven public art projects in the Berlin exhibition *Die Endlichkeit der Freiheit* (figure 20). Signaled by a plaque before the empty lot at 15/16 Grosse Hamburger Strasse, Boltanski's project addressed a neighborhood marked not only by the irredeemable absence of its former inhabitants, the Eastern European Jewish immigrants who once worked, worshipped, and resided there, but by the destruction of many of its buildings, the once architecturally consistent urban landscape punctuated in the postwar period not only by *Plattenbau* housing, but by vacant lots where apartment buildings once stood. Through the mounting on abutting firewalls of plaques reminiscent of German death notices (supplemented at another location in the city, the Lehrter Bahnhof, by vitrines filled with archival documentation), Boltanski did nothing more than call attention to the missing house. His plaques insist upon an encounter with what was lost, an acknowledgement and recognition of that irredeemable absence.[34] But, even here, the comparison falters, as Boltanski's project, for all of the conceptual affinity, provides a kind of frame for seeing, for attending to absence, without any attendant materialization of that phenomenological, and in this instance, acutely historical condition.

Closer still, then, may be the work of an unaffiliated group of contemporary artists, all of whom may be linked for their shared pursuit of domestic space as representational subject and form. There is, for example, the work of the Cuban émigré artist Maria Elena Gonzalez. Deploying blue prints and floor plans as a means of mapping and materializing space, Gonzalez uses casts and molds to represent unseen architectures, lost pasts. A piece like her *Magic Carpet/Home* (1999) certainly shares with Whiteread's *House* an interest in the architectures of the working poor. A to-scale reproduction of the floor plan of an apartment in the Red Hook East Housing Project in Brooklyn, *Magic Carpet/Home* was installed in nearby Coffy Park. The undulating white-painted "carpet" of soft, fire-retardant black rubber material used in play-

FIGURE 20 Christian Boltanski, *Missing House*, 1990. Photo by the author.

grounds transformed the lived reality of public housing into a space of play and imagination.[35] Similarly, her *UN Real Estates* transformed a gallery space into an undulating sea of tiny cast concrete floor plans, *Flying Apartment Flotilla* (2002). And in her 2000 installation *Mnemonic Architecture,* at the Ludwig Foundation in Havana, Gonzalez produced, directly on the floor of the gallery, a reproduction, from memory, of the floor plan of her childhood home, a footprint fabricated from thousands of tiny glass beads, architectural rendering as a means of representing the site from which, as Cuban émigré, she is exiled. A companion piece of sorts, *Trans Parent Home I* and *II,* was composed of rubber casts of the footprints of Gonzalez's aunt's and parents' homes, indexical sign and architectural drafting technique in one.

Significant in these latter projects of Gonzalez is the fact that they simulate the indexical rather than enact it. For their relation to their subject is not constituted physically, through actual contiguity, or geometrically, mathematically, through the representational conventions of architectural drafting, but psychically, physiologically, through memory.[36] In these works of memory, these works *from* memory, Gonzalez establishes a sculptural relation not to actual architecture but to the architectural archive that is (her) memory, which may be, for its utter lack of trace in the realm of the real, just as easily, fiction, and certainly is, if process is any indication, fabrication.

And it is this act of fabrication, dramatized and amplified in the actual use of fabrics as a means of reconstructing past and present homes, that defines a body of work by the Korean artist Do-Ho Suh. Sewn from silk and as mobile as the diasporic subject who creates them, such a work as *Seoul Home/L.A. Home/New York Home/Baltimore Home/London Home/ Seattle Home/L.A. Home,* 1999 (figure 21) recreates as diaphanous architectural space of his familial home in Korea, a house that was already a recreation, modeled as it was on his father's 1970s creation of a house that was a careful duplication, down to the recycled materials, of what had been a civilian-style house on the grounds of the palace complex in Seoul.[37]

Both Gonzalez and Suh create sculpturally something of what another contemporary artist, Toba Khedoori produces in large-scale drawing. Khedoori's exacting renderings of architectural fragments— doorways, windows, and sections, as, for example, her very own 1995 *Untitled (detail of House)*—might well be the documentary traces, the paper trail, the architectural plans, of Matta-Clark's urban and suburban activities of the 1970s, were they not rendered entirely from the realm of the imagination. That is to say, Khedoori's work is not a trace of the real, its index, its blueprint, but instead, pure visual fiction.

FIGURE 21 Do-Ho Suh, *Seoul Home/L.A. Home/New York Home/Baltimore Home/London Home/Seattle Home/L.A. Home,* 1999. Silk and metal armatures 149" × 240" × 240". Courtesy of Lehmann Maupin Gallery New York. The Museum of Contemporary Art, Los Angeles. Purchased with funds provided by an anonymous donor and a gift of the artist.

Similarly, James Casebere's massive photographs of eerie, empty, sometimes flooded architectural interiors of rooms, tunnels, and hallways would seem to document abandoned architectures, lit for photographic sessions that could just as easily house the theatrical antics of the Wilson twins (figure 22). But unlike the Wilsons' filmic interventions, Casebere's architectural sites are nonexistent. They are merely built models, quite diminutive in scale, stripped of distracting detail, and then aggrandized, monumentalized, in their photographic representation. Evocative of historical moments and monuments—sewers beneath the streets of Paris, bunkers beneath a wartime Berlin, Portuguese "slave factories" in West Africa, pristine and puritanical institutional spaces in New England—the photographs of these architectural interiors bear no relation, beyond suggestion, to the real, even as the photographs themselves, as objects, would seem to testify to their having been.[38]

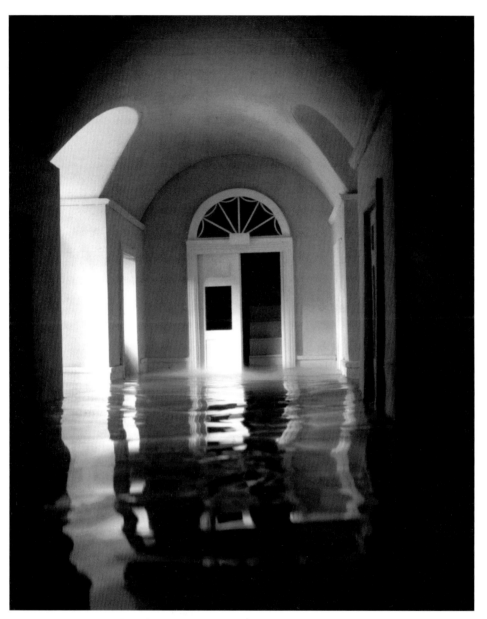

FIGURE 22 James Casebere, *Pink Hallway #3,* 2000. Courtesy of Sean Kelly Gallery, New York.

This faking of the index, this performance rather than production of the index, is, in effect, what may, in the end, structure Whiteread's work as well, as is made utterly manifest in a work like her *Untitled (Room),* which, like *House,* is also of 1993. Cast from a plywood mold as opposed to an actual room (as, for example, was *Ghost* in 1990), *Un-*

titled (Room) does not so much strip the cast object of any of the remaining textures or traces of actual lived architectural spaces, as reveal the cast object to be a materialization of a nonentity, that is, pure absence, the void that is space, the lacuna that is the history of the unrepresented. An utterly generic space, a box that would fully repeat the sculptural forms of minimalism were its surface not punctuated by the protrusion of what were the empty spaces within the window frame and the doorway, *Untitled (Room)* instantiates what Whiteread's other architectural works only intimate. There are no subjects here. Instead, there are only ghosts, lost histories fossilized, the lives of women obliquely monumentalized, sculpture as sepulcher.

* * *

As the novelist A. M. Homes has suggested of Whiteread's work, "if Rachel could drink a couple of quarts of plaster or pour resin down her throat, wait until it sets and then peel herself away, I have the feeling she would. She shows us the unseen, the inside out, the parts that go unrecognized."[39] Artistic act as a kind of architectural autopsy, Homes imagines for Whiteread an act of self-portraiture that demands the destruction of the subject, the death of the artist, an act of internalizing, interiorizing, ingesting the materials of casting that is as well an act of sacrifice, of suicide. That Whiteread's work demands an act of destruction, that the objects of her casting process are generally sacrificed to the exigencies of artistic production and the ambitions of aesthetic realization is another aspect of their peculiar logic. These are acts of preservation, of commemoration, that are, at the same time, acts of sacrifice, of letting go. If the sculptural object obliterates the original, the calcified remainder is, for all of its material properties, closer, then, to cinder than cement, closer to that ashen yet material trace of utter evacuation. For what remains in Whiteread's work is absence, doubly, an object destroyed and the nothing that is its surround, pure space, made matter. A condition compounded in the case of *House,* where both object and its sculptural other were, in the end, demolished, her work emerges from an attention to the object that is, at the same time, an enactment of destruction.

The calcified, hollow remains of domesticity that structure Whiteread's work find an interesting sculptural counterpoint in the work of Whiteread's compatriot, Cornelia Parker. In 1991, between Whiteread's completion of *Ghost* and *House,* Parker collaborated with the British Army to produce a room of her own, namely, *Cold Dark Matter: An Exploded View.* First captured photographically, Parker's subject was a

simple shed, filled with gardening tools, lumber, various discarded household objects and, to underscore its relation to the province of memory, a copy of Marcel Proust's *Remembrance of Things Past*. Rather than document the contents of an actual shed, an actual life, the objects in Parker's shed had been gathered from rummage sales and flea markets, the artistic staging of yet another fictive life, another fictive space. Phase two was to transport the shed to the army's School of Ammunition, where, with the help of army personnel, a controlled explosion was performed. The ashen splinters were then gathered and suspended on thin wires from the gallery ceiling in a room next door to the photograph of the original (figure 23).[40]

Where Parker's almost theatrical conceptual work offers up the photographic trace of the personal (albeit here, utterly fictive) only to destroy it with fire, Whiteread's work fully refuses to depict its presumptive subject, even as it relentlessly pursues the spaces of domesticity. Whiteread's work adamantly avoids the almost prurient possibility of revealing too much of the domestic interior, the space of private life. In casting negative space, Whiteread's work materializes a space of quotidian activity while at the same time refusing its actual mimetic representation. Fossils rather than figures, Whiteread's work reveals not the intimate details of domestic life and domestic lives, but instead, the simple fact that such lives had been lived. And that refusal to represent the lives lived, that withholding of the details of lives past, makes clear that for all the closeness of the sculptural cast, for all of the ways that it literally touches its presumptive subject, the history of domesticity remains at an irredeemable and irrecoverable, if not also, ethical distance, the private domain of the past ultimately unavailable, inaccessible to the gaze of the present.

House as a trace of a former home is the material, inverted double of the domestic space—the historical space of women's lives, rendered through its casting in concrete an unattainable and uncanny other. The shed, Parker's shed, is already the peculiar other of the house, a space that is both part of and yet outside of the economy of the home, the shed a place of refuge, of retreat, of secrecy, the last vestige of the private realm, if not also, oddly, masculinity within the domain of domesticity. Reduced to cinders, suspended on wire, Parker's artistic act of arson destroys the shed, performs an act of cremation on the little house that had never been a home, a radical act of erasure, through an immolation, an incineration that produces the ashen trace, form consumed by fire, remainder without remains.[41]

Whiteread's *House* was born not of conflagration but of concrete, not from pyrotechnics but from pouring, her casting process calling for the

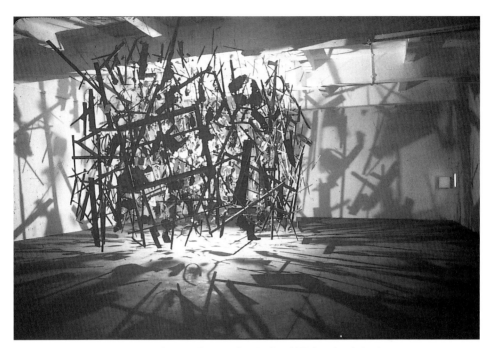

FIGURE 23 Cornelia Parker, *Cold Dark Matter: An Exploded View*, 1991. A garden shed and contents, blown up for the artist by the British Army, the fragments suspended around a light bulb. Courtesy of D'Amelio Terras.

flooding, the filling, of the empty center, the vacant spaces, that once made the house a home. And yet, like Parker's work and process, it comes into being through the destruction of its object, hastening the process of decay and deterioration, in order to remember. Whether sacrificial or sepulchral, both works materialize absence, as ash, as cast, transforming the private domain of domesticity into something sculptural, if not, in all respects, visible. For what remains is a marker of what cannot, what will not, be represented. What remains is a kind of monument, a form of memorial, all the more powerful for its unanticipated presence in the space of the gallery in the arena of contemporary art. What remains is a marking of the past all the more poignant for its unanticipated if oblique subject, namely, not history writ large, but instead, a trace of the domestic, an emptied and evacuated index of the everyday.

NOTES

CHAPTER ONE

1. Pliny the Elder, *Natural History,* trans. H. Rackham (Cambridge: Harvard University Press, 1938–69) book 35, passage 43, p. 373.

2. Pliny, *Natural History,* pp. 371–73.

3. Pliny, *Natural History,* p. 373.

4. See, for example, such essays as Thomas Lawson, "Last Exit: Painting" (1981), in *Art after Modernism: Rethinking Representation,* ed. Brian Wallis (York: New Museum of Contemporary Art, 1984) pp. 153–65 or Yve-Alain Bois, "Painting: The Task of Mourning" in *Endgame: Reference and Simulation in Recent Painting and Sculpture* (Cambridge: MIT Press and ICA Boston, 1986) pp. 29–49.

5. Certainly, an analysis of the aesthetic and disciplinary consequences of the positional difference between the female and male subject has been the project of nearly thirty years of feminist art history, even as more recent scholarship on performativity has produced both further clarity and complexity in that regard. See, for example, three anthologies edited by Norma Broude and Mary Garrard, *Feminism and Art History: Questioning the Litany* (New York: Harper and Row, 1982), *The Expanding Discourse: Feminism and Art History* (New York: HarperCollins, 1992), and *Reclaiming Female Agency: Feminist Art History after Postmodernism* (Berkeley and Los Angeles: University of California Press, 2005).

6. This lineage has been traced in far greater detail by Robert Rosenblum, in his "The Origin of Painting: A Problem in the Iconography of Romantic Classicism," *Art Bulletin* 39 (December 1957): 279–90.

7. Ann Bermingham, "The Origin of Painting and the Ends of Art: Wright of Derby's *Corinthian Maid,*" *Painting and the Politics of Culture: New Essays on British Art 1700–1850,* ed. John Barrell. (Oxford: Oxford University Press, 1992), pp. 135–65.

8. Geoffrey Batchen, *Burning with Desire: The Conception of Photography* (Cambridge, MA: MIT Press, 1997), pp. 112–20.

9. Victor Burgin's "Photography, Fantasy, Function" (1980), in Victor Burgin, ed., *Thinking Photography* (London: MacMillan, 1982) and Jacques Derrida, *Memoirs of the*

Blind: The Self-Portrait and Other Ruins, trans. Pascale-Anne Brault and Michael Naas (Chicago and London: University of Chicago Press, 1993).

10. Related to Burgin's inquiry, even if sharing none of his theoretical investment in desire, is Frances Mueck, "'Taught by Love': The Origin of Painting Again," *Art Bulletin* 81, no. 2 (June 1999): 297–302, which draws out the role of love at the origins of painting, by way of tracing the circulation among artists in England in the eighteenth century of a Latin didactic poem and demonstrating its influence on the emergent iconography of Cupid as the Corinthian maiden's teacher in visual representations of the legend of the origins of painting.

11. Charles Baudelaire, "Mnemonic Art," in *Painter of Modern Life and Other Essays,* ed. and trans. Jonathan Mayne (New York: Da Capo Press, 1986), p. 16–17.

12. Hubert Damisch, *Traité du Trait* (Paris: Réunion des Musées Nationaux, 1995) and Michael Newman, "The Marks, Traces and Gestures of Drawing," in *The Stage of Drawing: Gesture and Act,* ed. Catharine de Zegher (London and New York: Tate Publishing and The Drawing Center, New York, 2003), pp. 93–108. See also Newman's earlier, related essay, "Marking Time: Memory and Matter in the Work of Avis Newman," in *Inside the Visible: An Elliptical Traverse of 20th Century Art,* ed. Catharine de Zegher (Cambridge and London: MIT Press, 1996), pp. 271–79.

13. Victor Stoichita, *A Short History of the Shadow* (London: Reaktion Books, 1997), pp. 7–41.

14. Such is the argument put forth in Anna Chave's important critique of minimalism and, with that, of modernism, "Minimalism and the Rhetoric of Power," *Arts Magazine* (January 1990). For a broader account of minimalism, see James Meyer, *Minimalism: Art and Polemics in the Sixties* (New Haven: Yale University Press, 2001).

15. See, for example, the account of postwar German painting offered in my *Anselm Kiefer and Art after Auschwitz* (New York: Cambridge, 1999) as well as Robert Storr, *Gerhard Richter: October 18, 1977* (New York: MoMA, 2000) and *Gerhard Richter: Forty Years of Painting* (New York: MoMA, 2002).

16. See, for example, texts ranging from Francis Fukuyama's fundamentally conservative account, emerging from his belief in the "triumph" of liberal democracy, *The End of History and the Last Man* (New York: The Free Press, 1992), to Jean Baudrillard's emphatically postmodern renunciation of the real, *The Illusion of the End,* trans. Chris Turner (Stanford: Stanford University Press, 1994), to Ranajit Guha's postcolonial critique of Hegelian *Weltgeschichte, History at the Limit of World-History* (New York: Columbia, 2002). I am grateful to Madhavi Kale for introducing me to Guha's work. Finally, see as well, *The Postmodern History Reader,* ed. Keith Jenkins (London and New York: Routledge, 1997).

17. See, for example, such collections as Saul Friedlander, ed., *Probing the Limits of Representation: Nazism and the "Final Solution"* (Cambridge and London: Harvard University Press, 1992).

18. Cathy Caruth, *Unclaimed Experience: Trauma, Narration and History* (Baltimore: Johns Hopkins University Press, 1996), p. 7.

19. See, for example, W. J. T. Mitchell, *Picture Theory: Essays on Verbal and Visual Representation* (Chicago: University of Chicago Press, 1994); Daniel Abramson, "Maya Lin and the 1960s: Monuments, Time-Lines and Minimalism," *Critical Inquiry* 22, no.

4 (Summer 1996): 679–709; Kristin Ann Hass, *Carried to the Wall: American Memory and the Vietnam Veterans Memorial* (Berkeley: University of California Press, 1998); and Marita Sturken, *Tangled Memories: The Vietnam War, the AIDS Epidemic and the Politics of Remembering* (Berkeley, Los Angeles: University of California Press, 1997).

20. See Abramson, "Maya Lin and the 1960s," for a further elaboration of this argument.

21. See James Young, *The Texture of Memory: Holocaust Memorials and Meaning* (New Haven: Yale University Press, 1993) and his more recent "Memory and Counter-Memory: The End of the Monument in Germany," *Harvard Design Magazine,* Constructions of Memory: On Monuments Old and New (Fall 1999), pp. 5–13, which appears in edited form in his *At Memory's Edge: Afterimages of the Holocaust in Contemporary Art and Architecture* (New Haven: Yale University Press, 2000).

22. Hamilton's *bounden* consists of both the weeping wall and a set of nine embroidered gauze curtains, which stretch from the tops of the nine bay windows of the museum space to the structures of nine opposing prie-Dieu. The barely decipherable embroidered text is taken from *The Concise Gray's Anatomy,* Susan Stewart, "Lamentations"; Rebecca Cox Jackson, "A Dream of Slaughter"; Jorie Graham, "Self-Portrait as Hurry and Delay (Penelope at her Loom)"; and Angela Carter, "Company of Wolves." See the exhibition checklist in *Ann Hamilton: Present-Past 1984–1997* (Milan: Skira, 1998). Additionally, as Joan Simon contends in "Ann Hamilton: Inscribing Place" *Art in America* (June 1999), embroidered into the piece is a passage taken from Susan Stewart's poem, "The Spell," "Adam lay I—bounden, bounden in the glade" (*The Forest* [Chicago: University of Chicago Press, 1995], p. 30).

23. At the Contemporary Arts Museum, Houston in 1997–98, her installation *kaph* included two enormous, curving white walls, inside of which were 9,600 feet (1.8 miles) of intravenous tubing, attached to approximately 3,000 tiny orifices from which a mixture of distilled water and bourbon was seen to sweat, weep, or ooze. The bourbon used in *kaph* introduced smell into the piece, its musky scent producing an olfactory experience of the body, the walls turned a permeable skin. Though the smell of bourbon was fainter than anticipated, it left a different trace, light-brown trails upon the pristine white walls. For a discussion of the piece, see *Ann Hamilton, kaph* (Houston: Houston Museum of Contemporary Art, 1998).

24. *Ann Hamilton: whitecloth* (Ridgefield, CT: The Aldrich Museum of Contemporary Art, 1999).

25. Pierre Nora, "Between Memory and History: *Les Lieux de Mémoire,*" *Representations* 26 (Spring 1989). pp. 7–25.

26. Even more particularly, if not also, more literally, it may repeat a detail of Paolo Uccello's *Profanation of the Host,* the wound in the wall, in which we see the displacement of the wounding of the body of Christ onto the walls of the Jewish family in their house, awakening the community to the crime within. For elaboration, see Catherine Gallagher and Stephen Greenblatt, "The Wound in the Wall," *Practicing New Historicism* (Chicago: University of Chicago Press, 2000), pp. 75–109.

27. As a counterpoint to Hamilton's piece, one might think of an installation like Bill Viola's 1976 *He Weeps for You,* in which a droplet of water is at once tear and mirror, implicating the viewer in its mechanized life cycle.

28. See James Hoopes, ed., *Peirce on Signs: Writings on Semiotics by Charles Sanders Peirce* (Chapel Hill: University of North Carolina Press, 1991).

29. Rosalind Krauss, "Notes on the Index: Part I," and "Notes on the Index: Part II," in *The Originality of the Avant-Garde and Other Modernist Myths* (Cambridge, MA: MIT Press, 1985), pp. 196–209 and 210–19.

30. Certainly, the history, or prehistory, of photography and cinema makes that indexical relation to the subject of representation very clear. From the camera obscura and the magic lantern, to the phenakistiscope, the stroboscope, and the zoetrope, techniques of representation that find their origins in projection of a shadow onto the wall depend upon light *touching* their subjects. For a discussion of these early technologies and their relation to photography and cinema, see C. W. Ceram, *Archaeology of the Cinema,* trans. Richard Winston (New York: Harcourt, Brace & World, Inc, 1965); Laurent Mannoni, *The Great Art of Light and Shadow: Archaeology of the Cinema,* trans. Richard Cragle (1995; Exeter: University of Exeter Press, 2000); and Barbara Maria Stafford and Frances Terpak, *Devices of Wonder: From the World in a Box to Images on a Screen* (Los Angeles: Getty Research Institute, 2001). For a discussion of the indexical condition of the photograph, see André Bazin, "The Ontology of the Photographic Image," in *What is Cinema?* trans. Hugh Gray (Berkeley: University of California Press, 1967).

31. This indexical work of the 1990s, predicated as it is on absence rather than presence, represents a fundamental shift in the indexical logic of modernist practice, one which Rosalind Krauss traces in relation to a set of practices in the 1970s, in her "Notes on the Index 1" and "Notes on the Index 2" in *The Originality of the Avant-Garde and Other Modernist Myths* (Cambridge: MIT Press, 1985) pp. 196–209, 210–19.

32. Lisa Saltzman, *Anselm Kiefer and Art after Auschwitz* (New York: Cambridge University Press, 1999). See as well my subsequent essays, "Lost in Translation: Clement Greenberg, Anselm Kiefer and the Subject of History," in *Visual Culture and the Holocaust,* ed. Barbie Zelizer (New Brunswick: Rutgers University Press, 2001, pp. 74–88), "'Avant-Garde and Kitsch' Revisited: On the Ethics of Representation," *Mirroring Evil: Nazi Imagery/Recent Art,* ed. Norman L. Kleeblatt (New York and New Brunswick: The Jewish Museum, New York and Rutgers University Press, 2002), pp. 53–64, and "Gerhard Richter's *Stations of the Cross:* Martyrdom and Memory in Postwar German Art," *Oxford Art Journal* 28, no. 1 (Winter 2005): 25–44.

33. There is also the fine work of Ernst van Alphen, *Caught by History: Holocaust Effects in Contemporary Art, Literature, and Theory* (Stanford: Stanford University Press, 1977), which devotes a considerable amount of its attention to the work of Boltanski.

34. For a discussion of Attie's work, see, for example, *The Writing on the Wall: Projections in Berlin's Jewish Quarter,* essays by Michael Andre Bernstein, Erwin Leiser, and Shimon Attie (Heidelberg: Edition Braus, 1994), James Young, *At Memory's Edge* (2000), and Dora Apel, *Memory Effects: The Holocaust and the Art of Secondary Witnessing* (New Brunswick: Rutgers University Press, 2002).

35. *Judenplatz: Ort der Erinnerung* (Vienna: Jüdisches Museum der Stadt Wien und Pichler Verlag, 2000).

36. Here I gloss the words, and wisdom, of Roland Barthes, who writes in *Camera Lucida: Reflections on Photography,* trans. Richard Howard (New York: Hill and Wang,

1981), "History is hysterical: it is constituted only if we consider it, only if we look at it—and in order to look at it, we must be excluded from it. As a living soul, I am the contrary of History, I am what belies it, destroys it for the sake of my own history" (65).

37. The discussion will be specifically indebted to a lecture delivered by the artist at the Carpenter Center for the Visual Arts at Harvard University, November 14, 2002, titled "In Praise of Shadows."

38. Or course, Arad's memorial plan is only that, namely, a plan. Like Casebere's photographs of buildings that never were, Arad's plans give us a glimpse of images, sketches, and models of a memorial that may never be. Already much modified since his collaboration with the landscape architect Peter Walker, the spare, stark forms of Arad's barren memorial plaza have been softened by Walker's addition of pathways and trees. And the design has seen and will no doubt see further modifications, as introduced by the development corporation and its partners at David Brody Bond. In short, Arad's original plan, as it is adapted and refined to meet the demands of various constituencies, may well be as ephemeral as a temporary installation; it may exist only in the archive.

39. For a further discussion of representations of 9/11 see the epilogue to Lisa Saltzman and Eric Rosenberg, eds., *Trauma and Visuality in Modernity* (Hanover: Dartmouth College and the University of New England Press, 2006).

40. As of December 2005, the memorial pools that were designed to mark the absence of the twin towers will cover only 69 percent of the towers' actual footprints, leaving no indexical indication at ground level of where the towers once stood.

CHAPTER TWO

1. One might think as well of a subsequent piece, Ceal Floyer's 2002 *Autofocus,* that repeats something of McCall's cinematic project for the era and technology of slide projection. Setting projector in the gallery without a slide, the lens pursues the possibility of focus in the absence of an image, producing nothing but a shifting field of white light on the gallery wall.

2. Anthony McCall, "*Line Describing a Cone* and Related Films," *October* 103 (Winter 2003): 43.

3. See Barbara Maria Stafford and Frances Terpak, *Devices of Wonder: From the World in a Box to Images on a Screen* (Los Angeles: Getty Publications, 2001). The exhibition and its accompanying catalog proposed a set of genealogies for the visual technologies of the present. Less a strict history of optical developments and ocular devices than an exhibition staged as *Wunderkammer,* the dense display of 384 scientific and artistic objects established a matrix of influence and relation, in which the lensed, boxed, and projective apparatuses that were used to perceive and represent the world are at once artifact and antecedent. The exhibition and its catalog produce for an art historical context what such works as C. W. Ceram's, *Archaeology of the Cinema,* trans. Richard Winston (New York: Harcourt, Brace & World, Inc., 1965) and Laurent Mannoni's, *The Great Art of Light and Shadow: Archaeology of the Cinema,* trans. Richard Crangle, with an introduction by Tom Gunning (Exeter: University of Exeter Press, 2000) did for the field of film studies. See also Rebecca Solnit, *River of Shadows: Eadweard Muybridge*

and the Technological Wild West (New York: Viking, 2003). There is also the related 2005 exhibition and catalog, Darsie Alexander, *Slide Show: Projected Images in Contemporary Art* (Baltimore Museum of Art/Pennsylvania State University Press, 2005), which uses the technology of slide projection, a technology of the verge of obsolescence, to organize an account of the projected image in contemporary art.

4. Tony Oursler, "I hate the dark, I love the light," in *Tony Oursler: Introjection: Mid-career Survey: 1976–1999* (Williamstown: Williams College Museum of Art, 1999), pp. 102–11.

5. And to this history may be added the following observation, namely, that in the early years, homes and small gallery spaces, rather than large public spaces, were the venues for video, suggests something of a repetition of the intimate viewing spaces of the magic lantern and other early technologies of projection.

6. Large-screen projections appeared as early as the late 1960s, when artists used black-and white video projectors designed by Bell Labs to project thirty-foot-wide images on the walls.

7. His influence is perhaps most evident in the work of Shimon Attie, who has used the projection of still and moving images, as well as text, to create memorial interventions in urban environments, though, often, his work makes use of archival, rather than contemporary, testimonial, footage.

8. Rosalind Krauss, "Video: The Aesthetics of Narcissism," *October* 1 (Spring 1976): 51–64. See as well such anthologies as Doug Hall and Sally Jo Fifer, eds., *Illuminating Video: An Essential Guide to Video* (New York: Aperture, 1990) and Michael Renov and Erika Suderberg, eds., *Resolution: Contemporary Video Practices* (Minneapolis: University of Minnesota Press, 1996), and such exhibition catalogs as Chrissie Iles, *Into the Light: The Projected Image in American Art 1964–1977* (New York: Whitney Museum of American Art, 2001), and John Ravenal, ed., *Outer & Inner Space* (Richmond: Virginia Museum of Fine Arts, 2002).

9. Krauss, "Video: The Aesthetics of Narcissism," p. 51.

10. As Joselit writes in "On *Radical Software:* Tale of the Tape," *Artforum* 40, no. 9 (May 2002): 196, returning as well to Krauss's exemplar, Vito Acconci, "His "narcissism" if that is what it is—is a thoroughly social act that interpellates the spectator as an object and an other. The artists and theorists associated with *Radical Software* emphasized this other dimension of the video mirror. The reading of "narcissism" they produced is diametrically opposed to Krauss's."

11. That fiction is rendered all the more immediate, one might even say, real, with the advent of digital technology, in which the image is no longer predicated on any subject before a lens.

12. I should also mention here another article on video that engages the concept of the witness, Anne M. Wagner, "Performance, Video, and the Rhetoric of Presence," *October* 91 (Winter 2000): 59–90, even if Wagner's article, in an explicit return to Diderot and David, and with that, Michael Fried, pursues, by way of the "rhetoric of presence," the degree to which art is only constituted in presence of a spectator, a beholder, in other words, a witness.

13. In that respect, video is not dissimilar to the medium of photography, whose *noeme,* as Roland Barthes has so suggestively argued, is "that has been," in all its in-

tractability. See his *Camera Lucida: Reflections on Photography*, trans. Richard Howard (New York: Hill and Wang, 1981), pp. 89–119.

14. Here, I play intentionally on Freud's "screen memory," even if it is the cinema screen and the presumption of manifest content that are at stake in my account of Wodiczko's work. I should also make clear the context of Wodiczko's project. His installation was part of the inaugural round of temporary public art projects by Vita Brevis, an organization founded by Jill Medvedow, the director of the Institute of Contemporary Art, Boston. Other project sites were the Old North Church, inside of which New York artist Jim Hodges hung a series of wind chimes; the Old South Meeting House, where San Francisco artist Mildred Howard installed a pair of railroad tracks; and the Parkman Bandstand on the Boston Common, which Montreal artist Barbara Steinman decorated with large cloth banners bearing the images of sites and monuments on the Common. For more detailed descriptions of the project see Christine Temin, "Monument Message is Searing," *Boston Globe* (September 25, 1998) p. D1, Christine Temin, "Eloquent Video Airs Victims' Voices," *Boston Globe* (September 26, 1998), and Ken Shulman, "A Monument to Mothers and Lost Children," *New York Times* (September 20, 1998), pp. 40–41.

15. Krzysztof Wodiczko, Artist's Statement, *Assemblage* 37 (December 1998). This statement was also reproduced in exhibition materials accompanying its subsequent display at the Jewish Museum in New York in 1998, *Light x Eight: The Hanukkah Project*. The project may be seen in its entirety as a video produced by the Institute of Contemporary Art, Boston.

16. For an excellent social history of Charlestown (and Boston more generally), see J. Anthony Lukas's *Common Ground: A Turbulent Decade in the Lives of Three American Families* (New York: Alfred A. Knopf, 1985).

17. With Charlestown native Denis Leary as the leader of the small band of petty thieves and Colm Meaney as the local mob boss, whose controlling presence they at once respect and resent, the movie takes shape around the reigning neighborhood culture of Charlestown, namely, the code of silence. Billy Crudup plays a jumpy addict, whose early release from prison can only be understood as proof of his violation of that code, a snitch whose "unwitnessed" murder in a packed bar immediately dramatizes the local rule of law. Against that cultural code stands social code, personified by Martin Sheen, the Irish cop on the beat, determined to produce a witness for this crime, if not all those that preceded it—to produce speech to countermand the silence. Thus, even if it is Leary's mother, with a trace of an Irish brogue, who chastises her son about his silence in the aftermath of the most recent murder, stating: "All these mothers. All they've been through . . . You better believe I'd say something," it is Sheen who repeatedly, stubbornly, invokes the code of silence. Countering the words of the mob boss, "When are the cops gonna learn. This town doesn't talk," Sheen declares early in the film, "I'm gonna be here when somebody talks. This is still my beat," and later, "We'll keep coming over the bridge, 'til one of you opens your mouth and decides to talk." But no one does talk. Or, everyone does talk, at great length and often at great speed, in another homage, this time to Quentin Tarantino, but they talk about everything but the murders. And the film ends not only with silence but with a sense of mute resignation. For even as the murder of yet another neighborhood boy is

avenged with the killing of the mob boss and his henchman, justice has not been served, a fact made all the more tragic given the boy's identity. He is not any neighborhood boy, but a visiting cousin from Dublin, wrongly assumed to have cracked beneath Sheen's pressure and spoken of the murder he witnessed. Thus, the innocent cousin returns to Dublin a corpse. And the citizens of Charlestown remain trapped in their endless cycle of senseless murder and stubborn silence.

18. For a discussion by the artist of the *Bunker Hill Monument Projection,* see "Critical Vehicles," a lecture given by Wodiczko at Yale on March 30, 1999, an event which was recorded and temporarily archived at http://www.yale.edu/dmca/lectures99/wodiczko.html. Further references to this source and site will appear as "Yale Lecture" 1999.

19. In reference to an earlier project, his 1984 slide projection of missiles on the Memorial Arch at the Grand Army Plaza, Brooklyn, Ewa Lajer-Burcharth made the following comment, which might well be applied to the Bunker Hill Monument project, "For a moment at least, the 'necro-ideological monument' became alive." "A Conversation with Krzysztof Wodiczko," Douglas Crimp, Rosalyn Deutsche, and Ewa Lajer-Burcharth, *October* 38 (Fall 1986): 27.

20. See "Yale Lecture," 1999.

21. In addition to increased coverage during the early to mid-1990s in the Boston papers, including a series of articles in the *Boston Globe* by Kevin Cullen, *U.S. News & World Report* ran an article, jointly authored by David Whitman, Dorian Friedman, Amy Linn, Craig Doremus, and Katia Hetter titled "The White Underclass" (October 17, 1994). A primary source for the Boston portion of the article was Michael MacDonald, who would participate in Wodiczko's project and come to author *All Souls: A Family Story from Southie* (New York: Ballantine, 1999). MacDonald grew up in South Boston's notorious Old Colony housing project.

22. In addition to the ICA video, a full transcript of the projected testimony was provided at the Jewish Museum exhibition. It is from that transcript that this and subsequent citations are taken.

23. Michael MacDonald subsequently became known, as mentioned above, as the author of *All Souls: A Family Story from Southie,* a wrenching memoir of his childhood in the projects of South Boston. At the time of Wodiczko's project, his work with the group Citizens for Safety and organizing the gun buyback program put him in contact with the Charlestown After Murder Program. Their vigil inspired him to do the same in his own neighborhood. His book concludes with the vigil he organized in South Boston at the Gate of Heaven Church, and with the following words: "'These candles burn for my brothers.' I stopped and took a deep breath. Then I spoke up. 'Davey, Frankie, Kevin, and Patrick . . .' *And for all souls*" (263).

24. For a more subtle and expansive discussion of the rhythms of deferral and repetition that mark the "experience" of trauma, see Cathy Caruth, *Unclaimed Experience: Trauma, Narrative, and History* (Baltimore and London: Johns Hopkins University Press, 1996).

25. Primo Levi, "The Grey Zone," *The Drowned and the Saved,* trans. Raymond Rosenthal (New York: Random House, 1989). Levi's "The Grey Zone," advanced the controversial thesis that the survivor, whose condition is rendered most acute in the

particular case of the members of the *Sonderkommando,* survived, or survived longer, through their blurring of the subject positions of victim and executioner, the *Sonderkommando* working in the gas chambers and crematoria in a "zone of irresponsibility." Recent interest in the work of Levi is not only scholarly. The essay forms the kernel of a feature film by Tim Blake Nelson, also titled *The Grey Zone,* Lions Gate Films (2002).

26. Giorgio Agamben, "The Witness," *Remnants of Auschwitz: The Witness and the Archive,* trans. Daniel Heller-Roazen (New York: Zone Books, 1999), pp. 15–39.

27. I might note, here, the insistent masculinity of that subject position, something that Wodiczko's project, in both its emphatic insistence upon the voices of mothers, and, moreover, the projection of those female faces onto the forthrightly vertical façade of a monument to heroic masculinity, fundamentally undoes. I might also here mention a recent piece by Mona Hatoum, *Testimony* (2002), a video loop that is nothing more, or less, than a tight shot of its subject's testicles.

28. Levi, "The Grey Zone," pp. 83–84.

29. Earlier in his career, Wodiczko spoke of his memorial projections (which were "memorial projections" in their literal use of memorials as the site of projection, and executed with slides, not video). He described these "interventions" in the following terms, "The aim of the memorial projection is not to 'bring life to' or 'enliven' the memorial nor to support the happy, uncritical, bureaucratic 'socialization' of its site, but to reveal and expose to the public the contemporary deadly life of the memorial. The strategy of the memorial projection is to attack the memorial by surprise, using slide warfare, or to take part in and infiltrate the official cultural programs taking place on its site. In the latter instance, the memorial projection will become a double intervention: against the imaginary life of the memorial itself, and against the idea of social-life-with-memorial as uncritical relaxation. In this case, where the monumental character of the projection is bureaucratically desired, the aim of the memorial projection is to *pervert this desire* monumentally," "Krzysztof Wodiczko/ Public Projections," *October* 38 (Fall 1986): 10.

30. Rosalind Deutsche, "Sharing Strangeness: Krzysztof Wodiczko's *Aegis* and the Question of Hospitality," *Grey Room* 06 (Winter 2002): 35. For Levinas, see his *Totality and Infinity: An Essay on Exteriority,* trans. Alphonso Lingis (Pittsburgh: Duquesne University, 1969), p. 23.

31. For another discussion of the ethical dimension of the *Xenology* projects, see Ewa Lajer-Burcharth, "The Global Wanderer," in *4th Hiroshima Art Prize: Krzysztof Wodiczko* (Hiroshima: Hiroshima City Museum of Contemporary Art, 1999), pp. 133–41.

32. See Giorgio Agamben, "Beyond Human Rights," in *Radical Thought in Italy: A Potential Politics,* Paolo Virno and Michael Hardt, eds. (Minneapolis: University of Minnesota Press, 1996), p. 159.

33. Emmanuel Levinas and Richard Kearney, "Dialogue with Emmanuel Levinas," in *Face to Face with Levinas* (Albany: SUNY Press, 1986), pp. 23–24. For a discussion of Levinas's ethics of nonviolence, and the particularly "precarious" call of the Other's face, the face that at once tempts us with yet prohibits us from murder, see Judith Butler, particularly the chapter "Precarious Life," in her *Precarious Life: The Powers of Mourning and Violence* (London and New York: Verso, 2004), pp. 128–51.

34. In October of 2000, Oursler did do a public art installation, *The Influence Machine: A Nocturnal Installation of Video and Sound,* organized by Public Art Fund. The piece, which may be said to examine the differently immaterial worlds of spirituality and the Internet, was composed of a series of images, letters, voices, music, and sound, projected on and installed in the street lamps and trees of Madison Square Park, as well as on the corner column of the Metropolitan Life Building.

35. See Deborah Rothschild's exhibition catalog, *Tony Oursler: Introjection: Mid-Career Survery 1976–1999* (Williamstown, MA: Williams College Museum of Art, 1999).

36. Roland Barthes, *Camera Lucida: Reflections on Photography,* trans. Richard Howard, (New York: Hill and Wang, 1981), p. 65. For an interesting and productive application of Barthes's categories of history and hysteria, see Giuliana Bruno, "Ramble City: Postmodernism and *Blade Runner,*" *October* 41 (Summer 1987): 61–74.

CHAPTER THREE

1. One critic likened their scale to that of a doorway. Given their fundamental refusal to depict the human form, both the emptiness of the doorway and its function as a site of passage rather than containment, seem significant. See Richard Meyer, "Borrowed Voices: Glenn Ligon and the Force of Language," in *Glenn Ligon: Becoming,* ed. Judith Tannenbaun (Philadelphia: Institute of Contemporary Art, 1997), p. 13.

2. In addition to Tannenbaum's ICA Philadelphia catalog, see as well, Thelma Golden et al., *Black Male: Representations of Masculinity in Contemporary American Art* (New York: Whitney Museum of American Art, 1994). See as well David Marriott, *On Black Men* (New York: Columbia University Press, 2000).

3. For treatments of Johns and language, see Fred Orton, *Figuring Jasper Johns* (Cambridge, Harvard University Press) and Isabelle Loring Wallace, *Signification and the Subject: The Art of Jasper Johns* (PhD dissertation, Bryn Mawr, 1999).

4. See Frantz Fanon, *Black Skin, White Masks* (London: Pluto Press, 1986) and Alan Read, ed., *The Fact of Blackness: Frantz Fanon and Visual Representation* (Seattle: Bay Press, 1996).

5. My choice of words here alludes to Gwendolyn Dubois Shaw's *Seeing the Unspeakable: The Art of Kara Walker* (Durham and London: Duke University Press, 2004), to which my own meditations on race and representation are deeply indebted.

6. One might think here, as well, of Jeff Wall's photographic restaging of Ellison's *Invisible Man,* in his *After Invisible Man, by Ralph Ellison, the Prologue* (2001), in which he has illuminated the "the blackness of (his) invisibility" with 1369 light-bulbs, Wall's backlit light-box photograph rendering the invisible man dramatically visible.

7. I should note that on May 17, 2005, Ligon was one of twelve artists and scholars to be awarded, in its inaugural year, an Alphonse Fletcher Sr. Fellowship for work that contributes to furthering the goals of the landmark May 17, 1954 U.S. Supreme Court *Brown v. Board of Education* decision. The award will support a major painting cycle and video project titled "The Shadow," based on the Hans Christian Andersen story.

8. I should acknowledge here that I am in many ways indebted to the phrase "logic of spectrality," as articulated in the work of Jacques Derrida. See his *Specters of Marx:*

The State of the Debt, the Work of Mourning, and the New International, trans. Peggy Kamuf (Routledge: New York and London, 1994).

9. As quoted from the interview with Jerry Saltz, "Kara Walker: Ill-Will and Desire," *Flash Art* 29, no. 191 (December 1996): 82.

10. It is of additional interest that Etienne de Silhouette first appears as a public political figure as a member of a French delegation sent in 1749 to the New World to determine the frontier between British and French territory in Arcadia (now Nova Scotia). That the demarcation of borders was his first public act seems of interest, given the form that will later bear his name. See R. L. Megroz, *Profile Art through the Ages: A Study of the Use and Significance of Profile and Silhouette from the Stone Age to Puppet Films* (New York: Philosophical Library, 1949), p. 71.

11. I refer here specifically to such a work as *Les Ombres (Shadows)* (1986), which deploys projective light and suspended figurines at the gallery center to produce an installation of shadows upon the gallery walls.

12. See R. L. Megroz, *Profile Art through the Ages;* Marian Ackermann, *SchattenRisse: Silhouetten und Cutouts* (Munchen: Stadtische Galerie im Lenbachhaus, 2001); and Barbara Maria Stafford and Frances Terpak, *Devices of Wonder: From the World in a Box to Images on a Screen* (Los Angeles: Getty Center, 2001).

13. See Johann Caspar Lavater, *Essays on Physiognomy: Calculated to Extend the Knowledge and the Love of Mankind* (1775–1778), translated from the last Paris edition by C. Moore (London: 1797). See also, Ellis Shookman, ed., *The Faces of Physiognomy: Interdisciplinary Approaches to Johann Caspar Lavater* (Columbia, S.C.: Camden House, 1993).

14. See David R. Brigham, "The Audience for Silhouettes Cut by Moses Williams," in *Public Culture in the Early Republic: Peale's Museum and its Audience* (Washington, D.C.: Smithsonian Institution Press, 1995), pp. 68–82 and also, Dubois Shaw, *Seeing the Unspeakable: The Art of Kara Walker,* pp. 23–26.

15. Megroz, *Profile Art through the Ages,* p. 70.

16. Lothar Brieger, *Die Silhouette* (München: Holbein Verlag, 1921), p. 31.

17. Victor Stoichita, *A Short History of the Shadow* (London: Reaktion Books, 1997).

18. Ra'ad's *Dead Weight of the Quarrel Hangs* (1999) and *Hostage: The Bachar Tapes (English Version)* (2001) are part of a larger multimedia project created by the artist under the alias of The Atlas Group, a fictional foundation whose objective is to research and document, to produce an archive of, the contemporary history of Lebanon (see www.theatlasgroup.org). The videos combine the formal structures of traditional historical investigation—documentary film, photography, diaries, newspaper articles, statistics, testimony—with invention and interpretation, blurring fact and fiction. I am grateful to the Williams College Museum of Art and its 2003 exhibition *pol-i-tick,* curated by Lisa Dorin and Liza Johnson, for introducing me to Ra'ad's work.

19. Of course, the anonymity, or generality, of the silhouette is not always deployed as an act of resistance. As the 2005 advertising campaign for the iPod makes clear, the generality of the silhouetted form makes an image of various differentiated but by no means individuated youthful, dancing bodies, each plugged into his or her own physically tiny yet digitally vast archive of music, available to a range of potential consumers, each of whom may see him or herself reflected in these iconic everymen

and women. If there is individuation, it is on the inside, not on the outside, in the realm of the visible, as the sleek little iPod attests. Every iPod may be identical on the outside. But on the inside, each may be filled with a vast and utterly unique archive of music. That is where individuation lies.

20. Stoichita, *A Short History of the Shadow.*

21. The quote from a widely circulated letter, authored shortly after Walker was given a MacArthur award, is reproduced in Juliette Bowles, "Extreme Times Call for Extreme Heroes," *International Review of African American Art* 14 (1997): 4.

22. "Unfinished Business: The Return of Aunt Jemima," in *Betye Saar Workers-Warriors, The Return of Aunt Jemima* (New York: Michael Rosenfeld Gaalery 1998), p. 3, as cited in "Reading Black through White in the Work of Kara Walker: A Discussion between Michael Corrie and Robert Hobbs," *Art History* 26, no. 3 (June 2003): 441n16.

23. Walker's work was certainly at issue in the conference, "Change the Joke and Slip the Yoke: A Series of Conversations on the Use of Black Stereotype in Contemporary Visual Practice," March 18, 1998, as sponsored by the Harvard University Art Museums, the Carpenter Center for Visual Arts, the W. E. B. Du Bois Institute for Afro-American Research. The conference responded to and furthered the debate on the recycling of racist imagery, the collecting and exhibiting black memorabilia, the use of black stereotypes in the work of contemporary American artists and representations of blackness in film and theater. Among the panelists were such academics, artists, curators, and filmmakers as Michael Ray Charles, Henry Louis Gates Jr., Thelma Golden, Reggie Hudlin, Isaac Julien, David Levinthal, Glenn Ligon, Ellen Phelan, Alison Saar, and Betye Saar.

24. As quoted in Bowles, "Stereotypes Subverted? The Debate Continues," *The International Review of African American Art* 15, no. 2 (1998): 45. See also David Joselit, "Notes on Surface: Toward a Genealogy of Flatness," *Art History* 23, no. 1 (March 2000): 19–34.

25. Homi Bhabha, "The Other Question: Stereotype, Discrimination and the Discourse of Colonialism," in *The Location of Culture* (New York: Routledge, 1994), pp. 67, 70.

26. For a penetrating account of how the racial discourse of the antebellum period continued to shape the postemancipation period, producing a travesty of freedom, see Saidiya V. Hartman, *Scenes of Subjection: Terror, Slavery, and Self-Making in Nineteenth-Century America* (New York and Oxford: Oxford University Press, 1997).

27. *Gone,* included in the Drawing Center show *Selections Fall 1994: Installations,* September 10–October 22, was Walker's first piece to be exhibited in New York, having been exhibited in the previous three years in Atlanta (her hometown), Ashville, North Carolina, Boston, and Providence, where she was a student at the Rhode Island School of Design.

28. Walker speaks specifically of her relation to the form of the cyclorama, which, dating to the 1880s, took the form of a monumental continuous painting, installed in a circular room or rotunda. Atlanta, the site of her later childhood, adolescence, and undergraduate experience, was one of the few cities in America with a remaining cy-

clorama, *The Battle of Atlanta.* Walker herself says the following of the cyclorama: "Well, from the moment that I got started on these things I imagined that someday they would be put together in a kind of cyclorama. I mean, just like the Cyclorama in Atlanta that goes around in an endless cycle of history locked up in a room, I though it would be possible to arrange the silhouettes in such a way that they would make a kind of history painting encompassing the whole room" (as quoted in Alexander Alberro, "Kara Walker," *Index* 1, no. 1 [1996]: 26).

29. Mark Reinhardt claims, while at the same time acknowledging a conversation with Darby English, that this masculine side of the disembodied portrait bust resembles Abraham Lincoln. See his, "The Art of Racial Profiling," in *Kara Walker: Narratives of a Negress,* Ian Berry, Darby English, Vivian Patterson, and Mark Reinhardt, eds. (Cambridge, MA: MIT Press, 2003), p. 112.

30. See E. H. Gombrich, *Art and Illusion: A Study in the Psychology of Pictorial Interpretation* (Princeton: Princeton University Press, 1960), pp. 5, 238.

31. Think, for example, of a classic text of the Harlem Renaissance like Nella Larsen's *Passing* (New York: Modern Library, 2000). Or, to name but one of the most recent fictional accounts of passing, see Philip Roth's novel *The Human Stain* (Boston: Houghton Mifflin, 2000), in which the decision of the young black man, Coleman Silk, to pass for a Jew comes to haunt his later academic life, when he is accused, in a bizarre twist of fate, of having uttered anti-Black slurs. One might think as well of the life of Anatole Broyard, editor of the New York Times Book Review, whose own history of passing is explored by Henry Louis Gates Jr. in his "The Passing of Anatole Broyard," in *Thirteen Ways of Looking at a Black Man* (New York: Random House, 1997), pp. 180–214, a passing and refusal of an African-American identity that finds its ways into Broyard's own memoir, *Kafka Was the Rage: A Greenwich Village Memoir* (New York: Vintage, 1997).

32. I am grateful to Isabelle Wallace for offering this insight regarding the photographic negative.

33. See Margaret Carroll, "The Erotics of Absolutism: Rubens and the Mystification of Sexual Violence," in Norma Broude and Mary D. Garrard, eds., *The Expanding Discourse: Feminism and Art History* (New York: Harper Collins, 1992), pp. 138–59.

34. Kara Walker speaks of this motif of the swan, which recurs in her work, most manifestly and frequently in 1999–2000 silkscreen portfolio and in the University of Michigan Museum of Art 2002 installation, *The Emancipation Approximation,* in the following terms: "I was trying to make up mythology, and deconstruct it at the same time. I was using classical iconographic things like swans alluding to Leda and the Swan, and hermaphrodites. And I was making hybrid animals as well." See Annette Dixon, "A Negress Speaks Out," in her edited catalog, *Kara Walker: Pictures from Another Time* (Ann Arbor: University of Michigan Museum of Art, 2002), p.14, and Alexander Alberro, "Kara Walker" *Index* 1 (February 1996): 25–28.

35. For a discussion of what he considers the desire in American cultural life for essentially pornographic depictions of interracialism, see Robert F. Reid-Pharr, "Black Girl Lost," in *Kara Walker: Pictures of Another Time,* pp. 27–41.

36. As quoted in Hilarie M. Sheets, "Cut It Out! Kara Walker's Cutout Silhouettes of Antebellum Racial Stereotypes are Lewd, Provocative – and Beautiful," *ArtNews* 101, no. 4 (April 2002): 126.

37. There is some debate over how an image like *Cut* (1998), may be read. See, for example, Gwendolyn Dubois Shaw, "Final Cut," *Parkett* 59 (2000): 128–37, which compares the piece to a 1997 *Interview* magazine photograph of Walker, in which she is clad in a Comme des Garcons outfit, part Mammy part slave woman, and captured in a Samboesque posture, and Darby English's attendant critique, "This is not about the Past: Silhouettes in the Work of Kara Walker," *Kara Walker: Narratives of the Negress* (Cambridge: MIT Press, 2003), pp. 143–45.

38. Not only is *Fibbergibbet and Mumbo Jumbo: Kara E. Walker in Two Acts* Walker's first piece to include performance—her own and that of her cousin, James Hanna-han—a seven and a half minute staging of an overheard conversation, in a runaway's campsite in a swampy southern marsh. But it is also the first to include, in addition to miniature cycloramas and "magic lanterns," video and video projection.

39. See Liz Armstrong's interview with Kara Walker in *No Place (Like Home)* (Minneapolis: Walker Art Center 1998), p. 108.

40. For a discussion of this image and the "plantation family romance" depicted in *The End of Uncle Tom,* see Joan Copjec, "Black Baroque," in "Moses the Egyptian and the Big Black Mammy of the Antebellum South: Freud (with Kara Walker) on Race and History," in *Imagine There's No Woman There: Ethics and Sublimation* (Cambridge: MIT Press, 2002), pp. 98–104.

41. As quoted in Sidney Jenkins, *Look Away! Look Away! Look Away!* (Annandale-on-Hudson, New York: Center for Curatorial Studies, Bard College, 1995), p. 26.

42. Darby English, "This Is Not About the Past: Silhouettes in the Work of Kara Walker," in *Kara Walker: Narratives of a Negress,* Ian Berry, Darby English, Vivan Patterson, and Mark Reinhardt, eds. (Cambridge, MA: MIT Press, 2003), p. 158.

43. *Without Sanctuary: Lynching Photography in America* (Santa Fe, NM: Twin Palms Publishers, 2000), with essays by James Allen, Hilton Als, Jon Lewis, Leon R. Litwack. See as well David Marriott's chapter, "'I'm gonna borrer me a Kodak': Photography and Lynching," in his *On Black Men,* pp. 1–22.

44. Such a recognition of the other, even if it is, inevitably, a misrecognition, structures everything from Hegel's model of intersubjectivity and Buber's philosophy of the "I and Thou," to aspects of Adorno's aesthetic theory, elements of Levinas's ethics, and portions of Lacanian psychoanalysis; perhaps most to the point, it is absolutely key to the politics of multiculturalism in the present. For an insightful discussion of the ethics of recognition, as constituted both within a philosophical tradition and as it pertains to contemporary debates about multiculturalism, see Beatrice Hanssen, "Ethics of the Other," in *The Turn to Ethics,* Marjorie Garber, Beatrice Hanssen, and Rebecca L. Walkowitz, eds. (New York and London: Routledge, 2000), pp. 127–79 and *Multiculturalism: Examining the Politics of Recognition,* Amy Gutmann, ed. (Princeton: Princeton University Press, 1994), with contributions by, among others, Charles Taylor, K. Anthony Appiah, and Jurgen Habermas.

45. Rosalind Krauss, "'The Rock': William Kentridge's 'Drawings for Projection,'" *October* 91 (Spring 2000): 3–35.

46. For a penetrating account of memorial culture in South Africa since apartheid, see Annie E. Coombes, *History after Apartheid: Visual Culture and Public Memory in a Democratic South Africa* (Durham, NC: Duke University Press, 2003). See as well, Andres Mario Zervignon, "The Weave of Memory: Simeon Allen's *Screen* in Postapartheid South Africa," *Art Journal* (Spring 2002): 69–81.

47. William Kentridge, "The Body Drawn and Quartered" (unpublished), September 1998, as cited, courtesy of the artist, in Neal Benezra, "William Kentridge: Drawings for Projection," in *William Kentridge* (New York: Abrams, 2001), p.25.

48. William Kentridge, "In Praise of Shadows," a lecture delivered at the Carpenter Center for the Visual Arts, Harvard University, November 14, 2002.

49. These observations and ruminations on shadow play are taken from the same Carpenter Center lecture.

CHAPTER FOUR

1. First shown in Europe, *Crawl Space* had its U.S. debut in 1998 in the exhibition *Spectacular Optical,* curated by Lia Gangitano and organized by the Thread Waxing Space in New York.

2. One might also think here of Gregor Schneider's *Haus Ur,* a project in which the artist constantly destroys and rebuilds parts of the house in which he lives, a process which not only literally transforms the familiar into the eerily strange, but also raises the issue of entrapment in a perpetual present.

3. First and foremost, one should look to Sigmund Freud, "The Uncanny" *Standard Edition,* vol. 17 (London: Hogarth Press, 1955), pp. 217–56. For a treatment of the uncanny as it relates to modernity and modern architecture, see Anthony Vidler, *The Architectural Uncanny: Essays in the Modern Unhomely* (Cambridge, MA: MIT Press, 1992). For a theoretical encounter with haunted houses, as analyzed through the architectural metaphors that may be said to "ground" deconstruction, see Mark Wigley, *The Architecture of Deconstruction: Derrida's Haunt* (Cambridge, MA: MIT Press, 1993).

4. I should also note that the Wilsons are not alone in the 1990s in creating neo-Gothic works. An exhibition organized at the Institute of Contemporary Art in 1997 attests to the powerful presence of the neo-Gothic, of the haunted and macabre, in contemporary practice. See Christoph Grunenberg, ed., *Gothic* (Cambridge, MA: MIT Press, 1997). As does the aforementioned 1998 exhibition *Spectacular Optical,* curated by Lia Gangitano at the Thread Waxing Space. See *Spectacular Optical* (New York: Passim, Inc., 1998). For a discussion of this neo-Gothic sensibility in the Wilsons' films, see Gilda Williams, "Jane and Louise Wilson in the Light of the Gothic Tradition," *Parkett* 58 (2000), pp. 15–18. More generally, one might think of the contemporary moment, of art after modernism, steeped as it is in notions of belatedness and deferral, as haunted. As L. Ferry wrote, "Un spectre hante la pensé contemporaine: le spectre du sujet," *Homo Aestheticus* (Paris: Grasset, 1990).

5. For a discussion of the gothic, see, for example, Anne Williams, "Edifying Narrative: The Gothic Novel, 1764–1997," in *Gothic,* Christoph Grunenberg, ed. (Cambridge, MA: MIT Press, 1997). See also Jodey Castricano, *Cryptomimesis: The Gothic and Jacques Derrida's Ghost Writing* (Montreal: McGill-Queen's University Press, 2001).

6. See Juliann E. Fleenor, *The Female Gothic* (Montreal: Eden Press, 1983).

7. A 1997 exhibition at the Wexner Center, *Apocalyptic Wallpaper,* whose title plays on Harold Rosenberg's critique of the decorative possibility of abstraction in his "American Action Painters," explores the work of four contemporary artists for whom wallpaper has been at once a material, a motif, and conceptual concern. See *Apocalyptic Wallpaper: Robert Gober, Abigail Lane, Virgil Marti, and Andy Warhol,* ed. Donna de Salvo and Annetta Massie (Columbus, Ohio: Wexner Center for the Arts, 1997).

8. See, for example, such collections as Beatrice Colomina, ed., *Sexuality and Space* (New York: Princeton Architectural Press, 1992); Diana Agrest, Patricia Conway, and Leslie Kanes Weisman, eds., *The Sex of Architecture* (New York: Abrams, 1996); and Joel Sanders, ed., *Stud: Architectures of Masculinity* (New York: Princeton Architectural Press, 1996).

9. Of course, Whiteread's *House* was neither the first (think, for example of Richard Serra's *Titled Arc*), nor sadly the last instance of the destruction or removal of contemporary public art.

10. Between July 1993 and April 1994, no less than 249 related articles, reports, letters, and the like were published or broadcast, first exclusively in London, gradually in a range of European and American news sources and art journals. For a complete accounting of these sources, see "House Press," in *Rachel Whiteread: House,* ed. James Lingwood (London: Phaidon, in association with Artangel, 1995), pp. 140–43.

11. Notably, it was only in this particular moment, that is, in the aftermath of the destruction of Whiteread's *House,* that the Wilson twins took as their cinematic subject the private domain of the home. Of course, something of the domestic interior had appeared in prior work. But where a project like *Construction and Note* of 1992 used their apartment to document, in photographic and epistolary form, the scene of a staged crime, that site was but a backdrop, an available location, for the fictive scenario of detection played out therein. Not so in 1995, when they shot *Crawl Space.* For here, the abandoned Victorian house was itself as much the subject of the film as was the Gothic tale that transpired (literally) within its walls. An important work in their joint career in establishing architectural space as cinematic subject, *Crawl Space* was significant as well for its singularity within their oeuvre. For *Crawl Space* remains the Wilson twins' only piece in which the domestic interior, the space of the home, takes center stage.

From that point forward, the twins left behind the private realm of domesticity to produce a set of film and video installations that consistently explored the public sphere, taking as their subject and mise-en-scène such architectures and environments as governmental buildings, financial institutions, prisons, military bases, hospitals, sanatoria, aeronautic facilities, and athletic training grounds. A two-screen piece like their *Stasi City* (1997), for example, filmed within the former headquarters of the East German intelligence service in Berlin, engaged the history of a divided postwar Europe and used abandoned architecture to shed light on the material traces of history, most immediately a cold-war history of surveillance and documentation, if not also, the fascist past that preceded and produced it. Similarly, a five-screen piece like *Erewhon* (2004), organized around restaged archival footage of women exercising and

shot in both the neglected interior of a vacant sanatorium and the rugged and expansive landscape of the Western coast of the South Island, pursued ideologies of fitness, physical and psychological, in the aftermath of the World War I and in the context of colonialism in New Zealand.

12. See Louise Neri, ed., *Looking Up: Rachel Whiteread's Water Tower* (New York: Public Art Fund, 1999).

13. See Gerhard Milchram, ed., *Judenplatz: Ort der Erinnerung* (Wien: Judisches Museum der Stadt Wien und Pichler Verlag, 2000). See also, James Young, "Memory, Countermemory and the End of the Monument," *At Memory's Edge: After-Images of the Holocaust in Contemporary Art and Architecture* (New Haven: Yale University Press, 2000), pp. 90–119, and Andreas Huyssen, "Sculpture, Materiality and Memory in an Age of Amnesia," in *Displacements: Miroslaw Balka, Doris Salcedo, Rachel Whiteread* (Toronto: Art Gallery of Ontario, 1998).

14. There are, of course, exceptions to this career-long attention to the spaces of domesticity, such as her project for Trafalgar Square, *Monument* (2001), in which she was invited to work with an empty monumental plinth, once intended to ground an enduring marker of a minor monarch, William IV. Whiteread's solution to the eternally unrealized monument was to cast a replica of the marble plinth in clear resin and to mount it atop its base, the monument now completed with its ghostly mirror image, an absence made visible as transparence. For a discussion of the monument, see Chris Townsend, "Lessons from What's Poor: *Monument* and the Space of Power," in *The Art of Rachel Whiteread*, ed. Chris Townsend (London: Thames and Hudson, 2004), pp. 173–96.

15. For a discussion of Rodin's modernism, and the significance of his casting process, see Leo Steinberg, "Rodin," in *Other Criteria: Confrontations with Twentieth-Century Art* (New York and Oxford: Oxford University Press, 1972), pp. 322–403.

16. For a discussion of Rodin's use of bronze casting, and the degree to which it forced the fact of reproduction to inflect not just the creation of the multiple, but that of the "original," see Rosalind Krauss, "The Originality of the Avant-Garde," in *The Originality of the Avant-Garde and Other Modernist Myths* (Cambridge, MA: MIT Press, 1985), pp. 151–72.

17. See Georges Didi-Huberman, "'Figée à son Insu dans un Moule Magique . . .': Anachronisme du Moulage, Histoire de la Sculpture, Archeologie de la Modernité," *CAHIERS du Musée national d'art moderne* 54 (Winter 1995): 80–113. Among other points in this suggestive and ranging treatment of the "anachronism" of casting, its place before and outside of "art," Didi-Huberman makes the point that with the death mask, the logic of both the readymade and mechanical reproduction prove themselves to be as ancient as they are modern.

18. The catalog from the exhibition *Le Dernier Portrait* at the Musée d'Orsay in the spring of 2002, dedicated to "last portraits," be they death masks, paintings, or photographs, is a wonderful repository of images, essays, and sources. See Emmanuelle Heran et al, *Le Dernier Portrait* (Paris: Editions de la Reunion des Musées Nationaux, 2002). One might look as well to the foundational essay on wax portraiture by the Viennese art historian Julius von Schlosser, "Geschichte der Porträtbildnerei in Wachs.

Ein Versuch," in *Der Kunsthistorischen Sammlung des Allerhochsten Kaiserhauses* (Wien und Leipzig: Tempsky und Freytag: 1900/1911), pp. 171–258. (I am grateful to Cathy Soussloff for providing me with a copy of this essay.)

19. For a discussion of waxworks, see Marina Warner, "Waxworks and Wonderland," in *Visual Display: Culture Beyond Appearances,* ed. Lynne Cooke and Peter Wollen (New York: New Press, 1995), pp.178–201, and Michelle E. Bloom, *Waxworks: A Cultural Obsession* (Minneapolis: University of Minnesota Press, 2003).

20. One might think here, of the poem by the Israeli poet, Dan Pagis, "The Installing," from his 1982 collection, *Double Exposure,* as translated in "The Death Mask of the Moderns: A Genealogy of New Sensibility Cinema in Israel," *Israel Studies* 4 (Spring 1999).

> Death mask is installed
> from a negative of the face
> when the soul expires, you wrap
> the face with soft clay
> and slowly peel:
> so you are left with a large recess, and in it
> instead of the nose, a hole,
> instead of the orbits, molehills
> you pour plaster solution inside,
> wait for it to congeal,
> you sever, remove: the positive brings back
> the protruding nose, the sinking orbits
> now you place the plaster face
> over the flesh of your face
> and you live.

21. Here, it bears quoting Steinberg on Rodin, as a means of bringing out precisely how the casting process (as opposed to the sculptural process) mortifies its subject. "Rodin made some 150 small plaster hands, two to five inches long, for no purpose but to be picked up and revolved between gingerly fingers. Their modeling is of such tremulous sensibility that, by comparison, Rodin's own hand, preserved in a plaster cast at the Paris Museum, looks stiff and clodden—as would the cast of any real hand keeping still. But a living hand is in motion, and Rodin's little plasters simulate motion in two ways at least: first, by multiplied surface incident, which makes the light on them leap and plunge faster than light is wont to do; and again by the ceaseless serpentine quiver of bone and sinew, as if the sum of gestures which a whole body can make and all its irritability had condensed in these single hands; and their fingertips so earnestly probing that one credits them with total awareness and a full measure of life. There is in sculpture no surrender of privacy more absolute than when two of these small plaster hands lie together" (*Other Criteria,* p. 339).

22. Certainly, there are exceptions within her extensive oeuvre. For example, her casts of mattresses do not produce the surround, but instead, require two steps to reproduce the mattress as its ossified double.

23. This process of spraying concrete, used previously by the engineers of Atelier One, is known as "gunnitting." Normally, gunnite is designed to attach to existing structures. Here, it would form a structure only to be debonded from the extant building. For a thorough description of the process involved in the making of *House,* see Neil Thomas, "The Making of House: Technical Notes," in *Rachel Whiteread: House,* ed. James Lingwood (London: Phaidon, in association with Artangel, 1995), pp. 128–30.

24. For a discussion for site-specificity, see Rosalind Krauss, "Sculpture in the Expanded Field," in *The Anti-Aesthetic: Essays on Postmodern Culture,* ed. Hal Foster (Port Townsend, WA: Bay Press, 1983), pp. 31–42, and Miwon Kwon, *One Place After Another: Site-Specific Art and Locational Identity* (Cambridge, MA: MIT Press, 2002).

25. Charity Scribner makes a particularly compelling point about Whiteread's *House.* In the context of her book *Requiem for Communism* (Cambridge, MA: MIT Press, 2003), and a larger argument about the loss of socialism, she argues that Whiteread's project functioned to represent, to visualize, something of the postsocialist privatizations and foreclosures (in both economic terms and psychic [i.e., Lacanian] terms) of Thatcher's England.

26. Anthony Vidler discusses Whiteread's very particular relation to architectural space, and what he terms modernism's "spatial ideology" and its historical pedigree, by which he means space as a signifier of such ideas and ideals as democracy, hygiene, liberty, and safety—an opening up of the closed, dirty, dangerous, and unhealthy pockets of nineteenth century urbanism, if not also, architecture—an ideology that saw its adoption and perversion in totalitarianism. More specifically, Vidler relates Whiteread's *House,* as form, to Gestalt philosophy and an interest in figure/ground reversals, pointing toward the constructed plaster models of the Italian architect Luigi Moretti, which were cast, unlike most architectural models, as the solids of what were spatial voids. *House,* then, is effectively seen by Vidler as a "model" that resembles a number of paradigmatic modern houses, among them, those by Frank Lloyd Wright, Adolf Loos, Rudolph Schindler, and Paul Rudolph. See his "Rachel Whiteread's Postdomestic Casts," in *Warped Space: Art, Architecture, and Anxiety in Modern Culture* (Cambridge, MA: MIT Press, 2000), pp. 143–49.

One might also think here of Barbara Johnson's foundational essay, "Is Female to Male as Ground is to Figure?" in *The Feminist Difference: Literature, Psychoanalysis, Race, and Gender* (Cambridge, MA: Harvard University Press, 1998), pp. 17–36, which rephrases Sherry Ortner's famous feminist essay, "Is Female to Male as Nature Is to Culture?" to produce a reading of reading, an allegory of interpretation, as articulated through Hawthorne's "The Birthmark," Perkins Gilman's "The Yellow Wallpaper," and Freud's "Fragment of an Analysis of a Case of Hysteria."

27. For a discussion of shells, and their metaphors, see Gaston Bachelard, "Shells," in *The Poetics of Space,* trans. Maria Jolas (1958; Boston: Beacon Press, 1969), pp. 105–35. Bachelard's philosophical musings on space—from the house, to such interior spaces as wardrobes—bear a particular relation to the kinds of spaces explored sculpturally by Whiteread.

28. See Nicolas Abraham and Maria Torok, *The Shell and the Kernel: Renewals of Psychoanalysis,* vol. 1, ed. and trans. Nicholas T. Rand (Chicago: University of Chicago Press, 1994).

29. As Greg Hilty notes in his catalog essay "Thrown Voices," in *Doubletake: Collective Memory and Current Art* (London: Hayward Gallery, 1992), "Rachel Whiteread's sculptures are more evidently private monuments, in the form of plaster or rubber casts of impressions made, as if on the memory, by familiar objects that themselves have seen the presence of passage of people. Small scale cenotaphs (literally, 'a tomb without a body') their silences testify to the accumulated ineffable dignity of the everyday" (17).

30. For a discussion of contingency, with particular attention to the question of the copy and the process of capture and transmission, in Whiteread's work, and more generally in contemporary art, see Martha Buskirk, *The Contingent Object of Contemporary Art* (Cambridge, MA: MIT Press, 2003).

31. And here one might think of Heidegger's mediation on the jug, a vessel that is constituted through its relation to the emptiness within and the void that it holds, brought forth as a container in the shape of a containing vessel whose function is to hold liquidity and allow for its outpouring. See, Martin Heidegger, "The Thing," in *Poetry, Language, Thought,* trans. Albert Hofstadter (New York: Harper and Row, 1971), pp. 163–86.

32. In 1966, Nauman also produced *Space under My Hand When I Write My Name,* a yellow wax sculpture, now destroyed. See Joan Simon, ed. *Bruce Nauman* (Minneapolis: Walker Art Center, 1994).

33. For a discussion of the P.S. 1 exhibition "Rooms" in which these works were assembled and the semiotic status of the index in the art of the 1970s, see Rosalind Krauss, "Notes on the Index: Part 1," and "Notes on the Index: Part 2," in *The Originality of the Avant-Garde and Other Modernist Myths* (Cambridge, MA: MIT Press, 1985) pp. 196–209, 210–19. For a discussion of Gordon Matta-Clark, and his "unbuildings" as interventions not just into architectural space (and urban and suburban place) but into our postindustrial, collective imperative to waste, see Pamela M. Lee *Object to Be Destroyed: The Work of Gordon Matta-Clark* (Cambridge, MA: MIT Press, 2000).

One might also think of another postwar genealogy of casting, this one insistently figurative as opposed to architectural. From George Segal's full-body casts in the context of pop art, to the hyperrealist work of Duane Hansen, Charles Ray, and Ron Mueck, something of the legacy of casting, if not also, of Madame Tussaud's peculiar practice, is enacted in the postwar period.

34. Certainly, the Boltanski project is not alone in producing a memorial public art through the framing of absence. As James Young demonstrates in his field-defining *The Texture of Memory: Holocaust Memorials and Meaning* (New Haven: Yale University Press, 1993) and his subsequent study of post-Holocaust visual culture, *At Memory's Edge: After-Images of the Holocaust in Contemporary Art and Architecture* (New Haven: Yale University Press, 2000), the "countermonuments" of 1980s Germany and the visual practices of a subsequent generation of artists asserted absence and disappearance as an aesthetic mode of representing the destruction of European Jewry. For an exacting account of Boltanski's project, and other works in Berlin of commemorating the victims of fascism, see as well John Czaplicka, "History, Aesthetics and Contemporary Aesthetic Practice in Berlin," *New German Critique* 65 (Spring/Summer 1995): 155–87.

35. The project was repeated in Los Angeles in 2003, the floor plan of public housing again installed as a site of play in a public park.

36. For a ranging discussion of the operations of memory, see Daniel L. Schacter, *Searching for Memory* (New York: Basic Books, 1996). See also the collection of essays, *Memory, Brain, and Belief,* ed. Daniel L. Schacter and Elaine Scarry (Cambridge, MA: Harvard University Press, 2000).

37. For a discussion of Do-Ho Suh's work, see Miwon Kwon, "The Other Otherness: The Art of Do-Ho Suh," and Lisa G. Corrin, "The Perfect Home: A Conversation with Do-Ho Suh," in their catalog, *Do-Ho Suh* (London: Serpentine Gallery and Seattle: Seattle Art Museum, 2002), pp. 9–25, 27–39. In discussing Suh's movable architectural installations, Kwon challenges the claims of Krauss's "Notes on the Index," suggesting that when the indexical strategies used to create works that are no longer site-specific but mobile and itinerant, the signifying potential of the indexical may revert to the iconic.

38. One might think as well here of the work of the German photographer Thomas Demand.

39. A. M. Homes, "The Presence of Absence," in *Rachel Whiteread* (London: Anthony d'Offay Gallery, 1998), p. 35. One might think here as well of a work by another contemporary artist working in London, albeit in exile, the Palestinian artist Mona Hatoum, whose video installation *Corps Etranger* deploys an endoscopic camera to explore and make visible the unseen passages and cavities of the body, the metaphoric operations of the Wilsons' *Crawl Space* literalized.

40. The piece was, in some sense, repeated by chance when in 1997, during an artist residency in San Antonio, Texas, Parker was authorized to retrieve the charred remains of a church that, having been struck by lighting, had burnt to the ground. *Mass: Colder Darker Matter* was then joined in her oeuvre in 1999 by a third piece, *Hanging Fire (Suspected Arson),* its title indicative of its origins.

41. See Jacques Derrida, *Cinders,* trans. Ned Lukacher (Lincoln: University of Nebraska Press, 1991).

INDEX